THE CITY
OUT MY
WINDOW
by
MATTEO
PERICOLI

紐約的窗景，
我的故事

馬帝歐‧佩里柯利——著　廖婉如——譯

一個窗景，兩個故事。

窗外有故事在上演，窗內也有我的故事在發生……

● 1976 阿凱

　　傍晚約八點開始，台電大樓旁的空地上會準時出現一群阿姨跳舞，不管卡夫卡放的是 The National 或是 1976，往窗外看去總是合得上拍子，畫面上和諧有如音樂錄影帶的是 Bob Dylan 的音樂；靠近九點，年輕人開始在跳舞阿姨前的空地排隊，等待「河岸留言」他們支持的音樂人演出，這時候應該換上 Radiohead 才對。

　　雖然最熟悉的咖啡店消失，連鎖的書店與咖啡店進駐，附近蓋起了豪宅價位的住宅，住進也許沒有藝文喜好的鄰居……公館改變了，卻還在微妙地滿足我們對於生活經驗的各種期待，搖滾樂與文藝青年也還離不開，這是我在公館生活的第 12 年。

● 小樹（La Vie 專欄作家，StreetVoice 音樂頻道總監）

　　很慶幸自己能有幾群背景互異的友人。經常能在與他們聊談之間（無論是附議、反駁或聆聽），得到啟發；即使當下感到無趣的，不無日後恍然大悟的例子。

　　自身視角有限的人生，透過他者，於不同場景，我們得以觀看更多。

　　《紐約的窗景，我的故事》幾乎是上述情景的夢幻實踐：展書後便有眾家紐約名人圍繞，私密分享著各自住處前，那一片窗框裡的風景。經由他們的描述，竟也間接補充了關於紐約、非常個人觀點的建築與城市學。

　　進來一起坐吧！

●李清志（實踐大學建築研究所專任副教授）

　　從我的辦公室窗戶望出去，是一座綠意盎然的山。當我在城市中奔走疲倦，回到辦公室看著窗外的綠山，這座山每每都能撫平我急躁的思慮。對我而言，那是一座可以安靜人心的綠色山嶺。

　　不過這座山並非一直是如此綠意盎然，以前山坡上布滿了違章建築，違建上方則是死者居住的墳場，死人與活人並非想像中的天人永隔。不過後來土石流摧毀了違章建築，政府趕走了所有違建戶，並且在墳墓前種植更多樹木，如今樹木多已茁壯成蔭，遮住了看來令人害怕的墳墓，讓整座山重現綠意。

　　窗外的綠色山景是真實的，綠色下方的死人墳場也是真實的；有些真實看得見，有些真實看不見。不論如何，這就是從我窗戶望出去的風景。

●李俊明（設計與生活風格作家）

　　第一次「真正」注意到建築物上的門窗有多迷人，是走在遙遠的都柏林街巷上。儘管冷冷的風讓人不覺拉緊衣領，色彩與式樣極度鮮明的愛爾蘭門窗，卻牢牢抓住我的想像。

　　沒有想到的是，人生晃遊，竟又花了好多年，才學會從窗外走進窗內，用眼睛也用心來觀看。

　　直到那年秋天，赫爾辛基小木屋阻擋了芬蘭驟雨，手中正是濃湯微溫，口中呼出霧氣朦朧之時，我不經意瞥向窗外一片迷離，這才恍然醒悟：窗景迷人之處，不在於風景內容，只不過我們找到了安身立命角落，從那兒對我們熟悉的、陌生的、異國的、家鄉的景物，進行如同戀愛一般的凝視，並從距離中窺見了美感。

●杜祖業（GQ 雜誌總編輯）

　　以紐約為主題的書何其多，多到開間主題書店都不虞貨源匱乏，但好像很少有人像本書作者，透過窗戶來看紐約。走訪 63 位紐約客的家、工作室和辦公室，真的是個大工程，這個體驗也是極為特殊的，想想看走進 63 個人的私人世

界中，從他們的位置來看紐約，無論是形而上形而下都別具意義。人們看待自己所處的城市有很多種層次，但在高密度擁擠的水泥森林，每一扇看出去的景色都是不同的，有地產價值上的不同（面向公園或面向別人家後陽台），有高度角度的不同，有時為了一扇窗景，我們得付上更多倍的代價才能擁有。也許是作者人脈關係，書中出現的窗景的主人大多是文化圈人士，也讓每一頁簡短的文字充滿了睿智溫潤的氣質，想認識紐約的另一種風貌嗎？本書一口氣奉上63扇窗，很過癮的窺探經驗。

●馮光遠（知名作家）

當年在紐約，是怎麼都不可能從這麼多俯視的角度看這個城市的。那個時候拍紐約，很多時候都是「室外、仰視」的畫面，不像這本圖文書裡的「室內、俯視」視角。你可以安靜地從許多紐約客的窗子，用獵豹掃描草原的方式檢視窗外這個城市，她的靜止，她的流動，她的古舊，她的創新，每次都讓你重新認識她。

●黃寶蓮（知名作家）

即使你對這些人未必熟知，一扇窗卻能勾起人們對那個城市的聯想和好奇，從那一格一格的窗景裡，似乎也窺見了窗裡人點滴的心緒，處處充滿了窺探的好奇與驚喜。任何人即使未曾居住過紐約這個臥虎藏龍藏污納垢的城市，想必也會為這精彩的窗景而神往不已！

●黃威融（Shopping Design 總編輯）

本書的有趣，來自兩點：第一，他們談論的城市是紐約，誰會對紐約沒興趣呢；第二，參與的這群傢伙個個是讓人著迷的「好咖」。過去幾年，台灣的朋友對紐約的認識多半來自布朗克斯的洋基隊，其實這窄化了紐約的盛大和厚實。紐約的人事物文化藝術餐廳商店都讓人好奇，這些共同作者，個個都讓人想用Wiki 和 Google 查個詳細。若你對城市生活充滿期待和想望，千萬別錯過本書。

●楊子葆（輔仁大學客座教授）

　　城市性格最濃烈的窗，我以為是車窗。不管是大眾運輸的窗、捷運的窗、公車的窗，還是計程車的窗，乃至於小汽車的窗，坐在車裡駕駛的位置上或者乘客的位置上，我都喜歡欣賞窗外迅速流動、幾乎讓人分不清個別面貌的，人的容顏。那些歡喜、悲傷、專注、恍惚、悠哉、匆促、光鮮、樸素、老的、小的、男的、女的、insider 、 outsider ……，城市裡關於人的風景。

　　雖然從來沒有碰過，但我的心底時常默念著鄭愁予的詩句：「兩列車相遇於一小站／是夜央後四時／……／會不會有兩個人同落小窗相對／啊，竟是久違的童侶／在同向黎明而反向的路上碰到了。」

　　雖然從來沒有碰過，但我的心底時常期待。流動的城市，流動的窗景，流動的容顏。

（以上依姓氏筆畫序排序）

目錄

一座令人激動的回憶劇場

馮光遠

對居住紐約十多年的我來講，看完馬帝歐・佩里柯利這一本用黑白線條描繪出來的紐約窗景，滿足了我不少鄉愁。是的，鄉愁，紐約是我的第二故鄉。

當年在紐約，是怎麼都不可能從這麼多俯視的角度看這個城市的。那個時候拍紐約，很多時候都是「室外、仰視」的畫面，不像這本圖文書裡的「室內、俯視」視角。你可以安靜地從許多紐約客的窗子，用獵豹掃描草原的方式檢視窗外這個城市，她的靜止，她的流動，她的古舊，她的創新，每次都讓你重新認識她。

看到湯姆・沃爾夫在《紐約的窗景，我的故事》裡寫道，房地產仲介商帶著他妻子與他一起看房子，當看到後來成交的這一棟時，仲介商說，「你有沒有發現，每次我帶你看房子，你從沒看內部一眼，總是直接衝到窗邊看風景。」這敘述讓我回想到許多我的紐約朋友不也都是這樣，到了別人家（尤其是位於曼哈頓的公寓），幾乎都是先考察窗外的景色，又突然想到一個跟這有關的有趣之事：有回跟幾個朋友去上城哥大附近參加派對，從主人家客廳的窗子望出去，幾條街外有兩棟長得一模一樣的住宅大廈，寫詩的夏宇看著看著就問我，「光遠，那是世界貿易中心嗎？」我噗嗤一笑，「小姐，不是長得一樣的兩棟大樓都是世貿中心。」

可是佇立在窗口打量窗外風景，不管是夜晚遠眺帝國大廈頂樓紅白藍光，或者白晝近望克萊斯勒大樓從劍魚般尖塔反射出來的銀光，永遠都是一件讓人出神的事——若是你可以看到稱得上是經典建築或者自然美景的話。

《紐約的窗景，我的故事》書裡就有好幾個人描述到這樣的景況，作家菲力普‧洛佩特說，他其實很高興從他書房窗口望出去的景色「平凡無奇，不會美得讓人屏息」，因為如詩如畫的風景會讓他無法專心寫作；編導過《西雅圖夜未眠》、《美味關係》的諾拉‧伊佛朗講得更白，說從她辦公室落地窗望出去，可以看到她最喜歡的克萊斯勒大樓，「幸好我寫作時是背對著它，否則會半個字也寫不出來。」

　　窗外的風景的確會讓你沉浸在各種思緒裡久久不想動，尤其是在紐約這種城市，不盡然要在高樓櫛比鱗次的曼哈頓區，饒有文化感覺的布魯克林區、族裔鮮明的皇后區、具郊區風味的布朗克斯區，甚至是帶點世外桃源感覺的史泰登島，從各個人家窗戶望出去，再對照書裡各扇窗戶外的景觀，你突然會有一種領悟，原來紐約市做為世界級的文化藝術重鎮，窗外的風景竟然扮演著這麼重要的角色。

　　那也無怪乎希區考克的《後窗》觀念被書中好幾位作者提及，電影《後窗》裡，腿打上石膏坐在輪椅上竟日無所事事的攝影師詹姆斯‧史都華，從他位於曼哈頓下城西村的公寓後窗，不但看盡庶民生活百態，還見證一起謀殺案。

　　從後窗緊挨著後窗的公寓裡，紐約客一不小心就會看到故事，啟發靈感。傳記作家亞歷‧威金森就經常從他的窗子看到對面有二十個房間的名人的家居生活，並且好奇他經常在某個房間度過一天的最後時光的理由；鄉村搖滾歌手蘿珊‧凱許住在雀爾喜區，從她朋友住的雀爾喜飯店房間窗口，可以看到凱許的臥房，所以凱許喜歡跟先生在拜訪那位朋友時，從那個窗口反看自己的臥房；08年普立茲獎得主，《貧民窟宅男的世界末日：奧斯卡‧哇塞短暫奇妙的一生》作者朱諾‧迪亞茲更是在書中寫道「在這麼高的地方，窗子不再是窗子，反倒像窺視孔。這是如假包換的『後窗』，獨不見美侖美奐的房子，也不見人性光輝。」

　　所以，誰說文化藝術不就是從這些點點滴滴的「窺視」開始累積，漸次成形，終至無限開展？

　　一邊閱讀本書，自己的窗景經驗也不時跳出來。初至紐約，我與畫畫的朋友合租布魯克林「公園斜坡」的公寓，就是作家克列柏‧克雷恩與他男友彼得居住的那一區，看到克雷恩家的窗景，八〇年代「公園斜坡」21 街的日子又鮮活起

來，不同的是，我居住的公寓後窗，跨過低矮的窗檻，就是一樓的屋頂。我喜歡搬張椅子坐在人家屋頂上喝啤酒，而我的室友習慣把比人高的畫布撐在人家屋頂上作畫。後來我搬到皇后區「陽邊」，從窗口望出去，看到帝國大廈頂層部分，七月四日，紅藍白三色總是異常耀眼。記得 1986 年紐約大都會棒球隊打敗波士頓紅襪隊奪得世界冠軍，紅藍白光也高掛曼哈頓上空提醒紐約客大都會的成就。

提這些，因為在本書裡，你會不時在各個角度的天際線看到帝國大廈，它出現在凱許家窗口，出現在建築師李察・麥爾辦公室和編舞家馬克・莫里斯家窗口。從平面設計師史地芬・薩格梅斯特的工作室窗口也看得到帝國大廈，因為他需要工作室的每個人都時時感受到自己生活在紐約的事實。這真是一個激勵人心的選屋條件。

呆看《紐約的窗景，我的故事》的各個窗景，十幾年紐約生活從不去深究、就這麼擦身而過的建築或生活細節，竟然也會從畫作裡冒出來。《錯把太太當帽子的人》的作者奧利佛・薩克斯原來住在格林威治村外沿的十三街，當年，我應該曾經過他的公寓；媒體人勞倫・札拉茲尼克住的那棟大樓旁邊有間很大的賣酒的店，我知道，因為我在畫作左下方瞄到古博聯合學院；以前經常去華盛頓廣場，看到從作曲家尼可・馬利的窗口望出去的廣場拱門，許多回憶紛沓而至，加上一直在研究他家到底在廣場的哪個角落，我因此在這頁待了好久。

佩里柯利的黑白線條工整，把書裡這些紐約客各自的窗景，不論複雜或簡單，都整理得有條不紊。想到他能夠登堂入室到許多人家裡，端坐窗前畫出城市的各個面貌，我想也只有在紐約這個不論文化或歷史都層次分明的城市才有可能成其事。

以前在《紐約時報》，後來在《紐約客雜誌》寫建築評論的保羅・高柏格為本書寫的引言是這本書有看頭的另一個理由。至於諸多文化人、作家、藝術家為自家手繪版窗景所寫的短文裡，《光影交舞石頭記——建築師李伯斯金回憶錄》作者，紐約新世貿大樓建築師丹尼爾・李伯斯金的窗景以及他的感想，我覺得最值得拿出來當作這本書的代表。

李伯斯金是這麼寫的：我窗前這片景捕捉到紐約的詩意。它飽含感情和幾何線條……而感情才是建築的靈魂。好一座讓人激動的回憶劇場。

借來的私房風景

黃寶蓮

我倚窗夠久，
早已習慣一個空寂的房間，而，
你的愛不過是老人袖口上的塵垢，
—— Leonard Cohen 歌詞裡憂傷的窗。

窗是浪漫愛情發生的場景，
窗是想像飛馳的靈感之泉，
窗是誘惑的源頭，也可能是犯罪的入口……，
窗是關於自由和夢想，孤獨和寂寞，歡樂與喧囂……。

　　人的一生中想必都住過不同的房子，在不同的城鎮，有過不同的窗景，每個人或多或少都擁有或大或小、或闊綽或窄促的窗；窗的存在連繫了心靈與外面的世界；人都害怕孤獨，害怕被世界隔絕；有了窗，讓光進來，讓風景留駐；窗也是為了等待，等待生活可能發生的奇蹟，等待愛情，等待四季的變化，等待未來或緬懷過往……。

　　在紐約的那些年，我在布魯克林的窗外有一片藍天，許多高大的落葉喬木，下雪的時候，天地一片灰濛；晴朗的夏夜，偶有流星墜落天際，窗前也來過鴿子和賊子，有過我的遐想和失落；二十年過去，那一扇窗的景物，生生猶在記憶裡，成為生命中恆常的一頁風景。

　　是因為戀戀難捨即將告別的窗景，畫家馬帝歐‧佩里柯利，造訪了六十三位和紐約淵源深遠的音樂家、建築師、博物館館長、舞蹈家、記者、哲學家、教

授、插畫家、藝評家、雜誌總編、視覺藝術家、醫生……，將他們私家窗景拍照入畫，成為這本《紐約的窗景，我的故事》，從這些窗口我們望見紐約既古典又摩登的建築特色，窺見了世界知名的地標景物，也讀到不同的人物的思維與訊息，看見了一般人看不到的私房風景。

作家科倫·麥肯說：「我總以為，我們開多少次窗，便可以編織出多少個不同的故事。」讓我這個在窗前眺望著高樓夾縫中六尺見方的海景，埋頭敲打鍵盤卻未必能寫出像樣故事的書寫者嫉妒而且汗顏！

前紐約市長 Ed. Koch 說：「我的窗可以讓陽光通行無阻地灑進來！」

簡單一句話語，有力的說明 Koch 居處的闊綽；寸土寸金的紐約，一扇向陽的亮麗窗口是何等優沃奢華！Koch 是個熱愛廣東烤鴨的老饕，更是典型的紐約客，他已經給自己在紐約選好基地，因為無法想像自己離開紐約，生是紐約人，死是紐約鬼！是這樣一個讓人愛得徹底，恨也決絕的極端城市！這裡富人窮人各得其所；難見天日的半地庫裡，其實也窩居著未來的藝術家、音樂家或者清潔工、售貨員。

攝影家安妮·萊博維茨，蘇珊·桑塔格生前的伴侶，住在最富歐洲情調的格林威治村，每天在某一個固定的時刻，後院的磚牆上會有一束慢慢成形的光影，是院子裡的無花果樹投影；她說是紐約獨有的「借來的風景」；彷彿在嘲諷自己債台高築，抵押了後半輩子所有作品的版權向銀行告貸的困窘現狀！

視覺藝術家巴拉斯可住在傑克森高地，被那裡的平整和寬闊震撼；那裡移民聚居，滿街都是印度人開的電器店、果蔬雜貨、賣沙麗的布店、餐館，整條街飄著咖哩香，連人身上流的汗也有辛香味。有段時間我經常去那裡，吃印度菜、買沙麗，也上印度人的當，那些聲名遠播的小騙子。

「我愛死了！」作曲家葛拉斯說：關於他窗前的水塔、冷氣機、排氣管，紐約的基礎設施盡在他眼底。不知是他絕頂的幽默還是誇張的牢騷？有多少人熱愛這些發出噪音和熱氣的笨重機器？除了木質水塔，勉強稱之為紐約天頂的特殊景觀。

導演伊佛朗擁有紐約最光耀照人的窗景，紐約市天際線上最受人喜愛的建築，貝扇型的頂尖啟發多少建築與創作的靈感？為紐約夜景鑲上一顆閃爍的鑽石；克萊斯勒大廈成為電影、文學、戲劇、音樂、廣告甚至流行時尚界中不斷被引用描述的對象，許多故事發生的背景，一座你不得不另眼相待的獨特建築。

誰說：汽車在天上飛馳？

就如我此刻寓居的香港半山窗景，馬路是在樓跟樓夾層裡的一條帶子，車輛上頭有天橋跨過，天橋上面是 6 乘 8 見方的海，海的上面是維多利亞港對岸的尖沙咀，天氣晴朗不受污染的時候，就可以看到高跟鞋形樣的文化中心；然後，有一小片切割的山景，像切塊的馬鈴薯那樣，還有山外被兩棟大樓夾壓成峽谷的天空，在高樓與高樓之間形成「樓谷」，也有老鷹翱翔穿越、名符其實的石屎森林。

樓上有樓，天外有天，汽車真的是在天空奔馳穿梭，我窗外的天上人間。

紐約是這樣一個豐富多元的城市，佩里柯利所描繪的窗景，既美麗兼具特色又經典，他細緻的筆觸展示了紐約多層次的空間感與建築結構之美，百老匯大道、華爾街、中世紀的修道院以至河濱公園的花香草綠，夕陽中的跨河大橋，教堂的尖塔……，無一不令人遐想、惹人艷羨。

這六十三幅窗景，絕對是獨一無二的紐約剪影，無疑也是閱讀紐約最獨特而私密的視角，因為這是從他人的窗戶所借來的風景，那些不論你如何熟悉紐約都不可能有機會看到的私房風景。

即使你對這些人未必熟知，一扇窗卻能勾起人們對那個城市的聯想和好奇，從那一格一格的窗景裡，似乎也窺見了窗裡人點滴的心緒，處處充滿了窺探的好奇與驚喜，一個人即使未曾居住在紐約這個臥虎藏龍藏污納垢的城市，想必也會為這精彩的窗景而神往不已！對於我這個過往的居民，不小心卻引發了一場泛濫決堤的懷舊之情！

紐約的窗景，我的故事

這風貌只屬於你，獨一無二

保羅・高柏格（Paul Goldberger）｜普立茲建築獎評論家

你可能以為，會把曼哈頓島的風光畫進七十呎的長畫卷裡，就像馬帝歐・佩里柯利在《曼哈頓上河圖》（*Manhattan Unfurled*）一書裡的壯舉，一定是偏愛大幅畫作的人。實則不然。《曼哈頓上河圖》的迷人之處，不在它視角遼闊，而是這些景象給人的親密感。佩里柯利以細膩筆觸描繪曼哈頓島水岸景致，其魔力在於他把這偌大城市變得既溫柔，又私密。眼下，在這本《紐約的窗景，我的故事》裡，他顯露了一種（在我猜想是）向來激勵他的動力：呈現我們每個人和這城市風景的私密聯繫，以及那些單純存在於那裡、非我們所創造卻又每天舉目可見的事物，是如何深刻地牽動著我們的生活。

還有什麼比城市風景更讓我們無從掌控？我們可以選擇不住某處，但它和我們大多數人挑選窗外風景時一樣選擇有限。我們一搬進去，就成了窗外景色的俘虜，不管它是廣闊的天際線、櫛比鱗次的屋頂、樓宇狹縫中的綠意，或像我很久以前短暫住過的公寓一樣——某座暗無天日的通風井。窗景就像室友，你一定要確定自己想和它共同生活，因為你改變不了它，而且你要有心理準備，它可能說變就變。

然而一旦你接納它，它就成為你的一部分，而你從中所見的便透露了一切。佩里柯利書中的這六十三位紐約客，都是住在不同地方過著不同生活的不同人物；他們眼中的窗外風景，不消說也是各異其趣。然而，他們跟佩里柯利談起窗外風景時，描繪多少免不了就顯露出自身多少。作家彼得・凱瑞（頁50）看到了他那一區的歷史，甚於街頭現今的一切；作曲家柏梅爾（頁40）只談耳裡聽見的聲音。人權運動家波格特（頁46）說她看著天空時，想的是遠方。音樂家大衛・拜恩（頁48）則想到他觀看別人的時候，也會有其他人觀看著他。神經

學家兼作家奧利佛‧薩克斯（頁 122）談到窗外哪些事物令他平靜，哪些事物會激發他思考。編輯兼作家桑南柏格（頁 130）瞥見川普大樓就不悅，看到哈德遜河畔日落就開心。塔利茲（頁 140）不愧是小說家，生動描述他不雇工人洗窗，寧可從蒙上塵垢的窗看朦朧街景的原委。還有作家兼教授史迪里（頁 134）抱怨窗太大、陽光也太多，要是不拉上窗簾，啥事都做不成。

這種心情我懂。受夠了只能望著通風井之後，我搬到一間開窗就能看見中央公園樹海的公寓。儘管我很愛這片夏天青翠、秋天橘紅、冬天與初春茫白的景——之前我從不曾察覺到城裡的四季變化——我卻還是讓書桌背對著窗，因為要是時時面向窗口，我不僅沒法專心，什麼事都沒法做，更糟的是，到頭來我會變成對這片景色視而不見。因此，每當我起身走到窗口，看風景遂成了一件大事。窗景絕不能淪為壁紙。

值得注意的是，佩里柯利的受訪者中沒幾人談到窗外的人。由此看來，若非他們心不在此，就是住在紐約其實不如你所以為的曝露在公眾視線中。這裡沒有《後窗》式的情節，其中最近似於「看到不該看的」情況，就是編輯洛林‧史坦看到（而且聽到）鄰居高歌，還有編舞家馬克‧莫里斯看見鄰人做愛。

城市居所，究竟是供人觀看世界的有利棲息處，還是讓人隱遁的洞穴？窗外的風景，是讓你與所見的世界產生連結，還是促使你沉思？理想上來說，兩者都多少有一點最好：你向外觀看世界，也向內觀看自己。在通風井和公園樹海這兩個極端之間，我住過一個公寓，它的角間是日光浴室，可以鳥瞰一大片屋頂。那樓層不是頂高，但是日光浴室仍高踞附近所有赤褐砂石樓房之上，而且四面幾乎都是玻璃，待在裡頭就像坐在盤旋空中的直昇機裡。大概是這緣故，我只想到自己往外看，卻沒想到我在那房間裡其實非常引人注目。

這裡的每一幅精緻畫作、每一段陳述，某個程度上都是關乎隱私，關乎城市生活必然會有的公私領域拉扯的一番見解。路易士‧孟佛（Lewis Mumford）曾經把城市比喻為「一座舞台，上演著社會生活戲碼，台上的人既是演員，也是觀眾。」而當他論及街坊生活，有可能就是在說我們當中許多人會望著窗外看，同時心知肚明有人也正望著我們。從我家廚房可以看見天井另一端對面人家的廚房。那戶人家搬來好幾個月後，我發現他們會觀察我和我家人的動靜，起初他們會假裝根本沒在看，後來我們心照不宣地默認彼此互窺後，偶爾還會揮揮手打招

呼。一回我在街上巧遇男主人，他竟打開話匣子跟我聊了起來，彷彿我們是舊識一般，而就某方面來説，我們也的確是。

　　如果説，《紐約的窗景，我的故事》字裡行間隱約透露出人們對自己的居所，以及對居所與世界的關係的一種反思（或一連串反思），那麼這本書無疑也是一本都市建築微型版的入門。佩里柯利筆下的簡潔線條，詳實描繪了每棟住宅的設計，而且還不僅止於住宅所代表的有形世界，煞是驚人。你會看到寇特・安德森（頁 26）住在一條美麗街道上的赤褐砂石樓房裡；羅傑・安哲（頁 28）和葛雷登・卡特（頁 52）的辦公室都在中城一棟新的摩天大樓裡（在同一棟，只是窗戶的方位不同）；諾拉・伊佛朗（頁 70）住在一棟典雅的老公寓大樓裡，而馬克・莫里斯（頁 114）住的公寓則新穎些。你會發現，窗戶的樣式賦予了畫面某種基調。（雖然佩里柯利的每一幅畫都將你的目光拉向窗外，但你的心思也會飄向窗內，努力想像這些房間裡是什麼模樣）

　　你看的風景若是從那些大型單片玻璃窗看出去的，你就感受不到建築和風景間討喜的對比；這類所謂的「風景窗」（picture window），少了你所在的樓宇建築和外在世界景致之間的微妙張力，很弔詭地讓窗外風景少了點魅力。這本書所描繪的風景，大多是從上下拉合的窗戶往外看的，這類窗戶會把視野分成上下兩半，但你的眼睛會將兩者結合，而中間那條水平線不過是個標點符號。如果你從平開窗（門式窗）或多窗格的窗戶望出去，你的眼睛也會自動將之合而為一，只不過這些窗格線會很突出，不免讓你更加意識到建築物本身。在這種屋子裡，窗戶本身很醒目，就像薩格梅斯特（頁 124）或巴瑞辛尼可夫（頁 34）的窗子那樣，但是你會別有一番體驗，感受到前景的窗戶樣式和背景的風景之間迷人的交互作用。你看見窗格線，隨後你的眼睛會讓這些格線慢慢消失，最後你看見了城市。如果窗戶樣式特殊，像彼得・班內特（頁 30）從修道院博物館的拱型窗眺望喬治華盛頓大橋一樣，也會歷經同樣的過程：你會先看見拱型線條，慢慢的這線條會在你眼裡消失，最後只剩窗外風光。

　　這本書無意鼓吹人要把自己的居所當成圈地＊看待，也無意強調不受建築物

・ enclosure，自十二世紀起，歐洲資產階級和貴族為了經濟利益，將公用田地乃至於小佃農的租地圈占為私有地，強占的私有地即「圈地」，史上稱為「圈地行動」，以英國最盛。此處指人的居所是人對公共空間進行圈分並私有化的結果，之後擁有的私有空間即為圈地。

稍微框限的廣袤風景會失去韻味。佩里柯利本來想把書名取為《窗即是框》（*Your Window Is Your Frame*），因為這正是他想表達的：你的窗口是你眼中世界風貌的框架，而這風貌只屬於你，獨一無二。

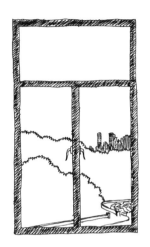

保羅・高柏格的窗景

這幅風景包含了我天天都想看到的事物：
天空、樹木、庭院，以及街上的行人。
對街的幾棟赤褐砂石樓房
多少映照出我們這棟的樣貌，
讓我安安心心、舒舒服服地沉浸在虛榮裡。

The view includes everything I require in an everyday view: sky, trees, gardens, people walking by on the sidewalk. And the several brownstones across the street are more or less mirror images of our own, which indulges my vanity in a sort of reassuring gemütlich way.

寇特・安德森｜小說家、電台主持人

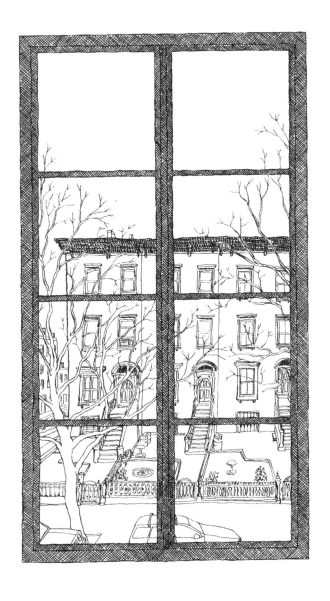

KURT ANDERSEN

我的窗景，
儘管是一大片看上去頗單調的建築物，
卻經常在變化，
多虧了陽光反射在數百扇各式窗戶上亮晃晃地躍動，
在午間過後灑落進來。
冬天，太陽在下午稍晚時滑落，
接下來的一個鐘頭左右，
時報廣場上粉紅的橘的綠的藍的銀的光色、炫麗的快訊
以及往下城移動的計程車頭燈
（起碼可以看到狹長的一部分），
從窗子的左下角湧現，
提醒我又是該回家的時候了。

My view, for all its architectural dreariness, is constantly altering, thanks to the
reflected sunlight, bouncing off hundreds of different windows, that pours in
here later on in the day. In the winter, the sun has slid away by late afternoon,
and in the next hour or so the pink and orange and green and blue and silver
hues and the garishly urgent messages and the moving downtown taxi head-
lights of Times Square (or at least a narrow strip of it) will come rising into view
from the lower left of my window, telling me that it's okay to go home again.

羅傑・安哲｜紐約棒球評論家

28

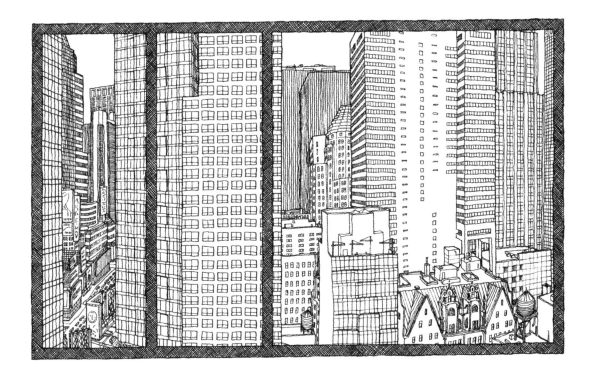

ROGER ANGELL

右邊鋼骨結構的喬治華盛頓大橋，

深得柯比意喜愛，

稱之為世上最美的橋。

這座橋在一九三一年落成，

比修道院博物館開館還早了七年，

後者是由從法國和西班牙運過來的中世紀建築元件建構而成。

我的辦公室就在修道院博物館的塔樓頂，

這間紐約大都會博物館專門收藏中世紀文物的分館，

四面地景都非常壯觀。

我這裡面南，從這兩片仿羅馬式窗戶望出去，

越過赤陶屋瓦以外，就是崔恩堡公園和哈德遜河。

面西的窗可以俯瞰河景和未遭破壞的斷崖，

天氣好的話，面北的窗可以看到塔潘齊大橋。

只有東邊的窗面向哈林河和布朗克斯區，

看到的是樓房密集的現代都會。

The steel span of the George Washington Bridge, on the right, was beloved by Le Corbusier, who called it the most beautiful bridge in the world. The bridge was dedicated in 1931, seven years before The Cloisters opened its treasures to the public in a building comprised of medieval architectural elements transported from France and Spain. My office atop the tower at The Cloisters, the branch of the Metropolitan Museum of Art dedicated to medieval art, has spectacular views in four directions. Here, we look south through a pair of Romanesque style windows across the terra-cotta roof tiles to Fort Tryon Park and the Hudson River. The west windows overlook the river and the unspoiled Palisades, and on a clear day the view north extends to the Tappan Zee Bridge. Only the view east over the Harlem River and the Bronx takes in the densely built contemporary city.

彼得‧班內特｜修道院博物館館長

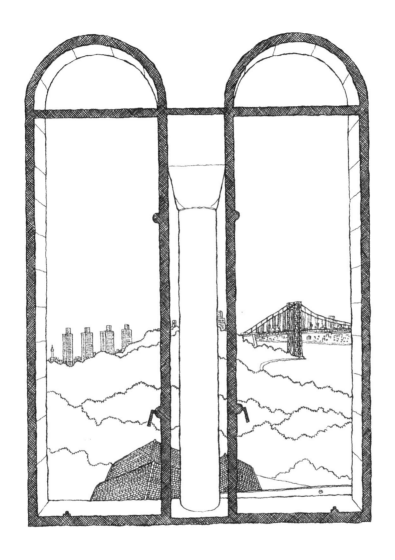

PETER BARNET

與其說我在看風景，
不如說我住在風景裡，
就像住在紐約這偌大的立體書裡一般。
百老匯大道、艾靈頓公爵大道和西區全在我們這街角交會，
營造出一種讓人聯想到巴黎那些林蔭大道的氛圍。
一早醒來什麼事都還沒做之前，
我會從窗簾後頭窺望，
順著百老匯大道看去，
聆聽這城裡的聲音、欣賞街頭景象。
外子和孩子們會跟我分享這窗景，
不管是從裡頭隔著窗向下方的家人揮手打招呼，
或是一同在窗前想像從下邊走過的路人過著怎樣的生活。
這扇窗給了我們一個作夢（以及觀察天氣如何以便預做準備）的框架。

Rather than looking at my view, I feel that I exist within it, like living in a pop-up book of New York City. Broadway, Duke Ellington Boulevard, and West End all converge on our corner, creating an atmosphere reminiscent of the big avenues in Paris. When I wake up, before doing anything else, I peek behind the shade, gaze down Broadway, and take in the sounds and sights of the city. My husband, children, and I share my view—whether we are waving at each other from the inside out or imagining the lives of the people who pass under us—the window provides a structure through which we can dream (and prepare for the weather!).

卡洛琳・貝倫｜製片、慈善家

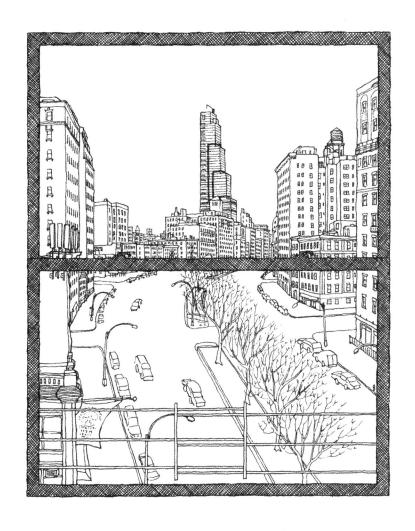

CAROLINE BARON

它是紐約最美的建築之一，
晚上看更美……
就和女人一樣。

It's one of New York's most beautiful buildings, but it looks better at night …
like a woman.

巴瑞辛尼可夫│芭蕾舞家

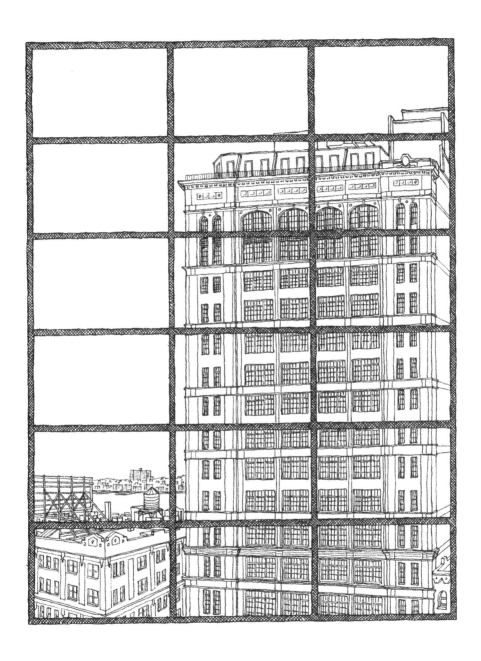

MIKHAIL BARYSHNIKOV

我們家窗口面向的華盛頓廣場一帶，
孕育了二十世紀中葉的流行文化……
拐個彎就可以走到西打客棧，
波洛克和杜庫寧、紐約大學學生、
巴布‧狄倫和吉米‧罕醉克斯、
艾倫‧金斯堡和「垮掉一族」
過去常在那裡出沒，
順著第九街走下去就是克里斯多福街和石牆事件發生地；
我們所熟知的世界在這裡誕生，
在這裡扎根，
也會在這裡茁壯進化。
這裡美極了，像天堂，狂亂又沉靜。
啊，我的公園現在有了新面貌，
而那該死的噴水池終於回復它應有的平靜。

Out our window the view toward Washington Square is the entire history of mid-twentieth-century pop culture ... around the corner to the Cedar Tavern of Pollock and de Kooning, NYU, Bob Dylan and Jimi Hendrix, Alan Ginsberg and the Beats, Ninth Street to Christopher and the Stonewall Revolution; the world as we know it is born here, lives here, will evolve here. It is beauty, it is paradise, it is frenetic and calm. Ahh, my park has a new face now and the damn fountain is finally at rest where it should be.

馬利歐‧巴塔立｜名廚

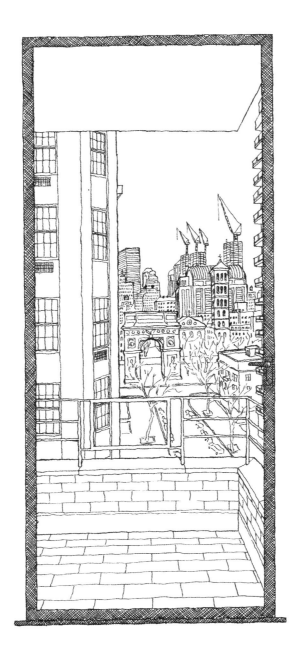

MARIO BATALI

我放眼望向住在那些公寓大樓，
以及連棟獨戶住宅、甚至畫室裡的人，
但是我用肉眼看不到他們。
我樂於想像他們是什麼樣的人、從事什麼行業。
如果用望遠鏡貼近地窺視他們，
不僅會違背不成文的都會生活規範，
說不定還會發現他們的真實生活遠不如我想像中的精采。

I look out at dozens of neighbors who live in apartment buildings, town houses, and even an artist's atelier, but I cannot see them with the naked eye. I am content to leave to my imagination exactly who they are and what they do. Peering at them up close through a telescope would not only breach an unwritten code of urban ethics, it would probably reveal their lives to be far less glamorous than I like to think they are.

約翰·伯蘭特 | 作家

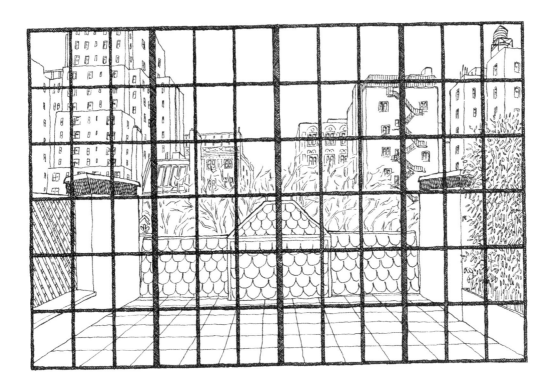

JOHN BERENDT

破曉，嘲鶇鳴叫；

早晨，軋軋響的卡車卸貨聲；

中午，樓下電視聲；

下午，鄰家小孩隱隱約約的嬉鬧聲；

傍晚，汽車警報器聲；

晚上，警笛聲；

之後，一片寂靜。

At dawn, a mockingbird; in the morning, a chugging truck unloading parcels; at noon, the television downstairs; in the afternoon, muffled shouts from kids playing next door; at dusk, a car alarm; at night, police sirens; then stillness.

德瑞克・柏梅爾｜豎笛家、作曲家

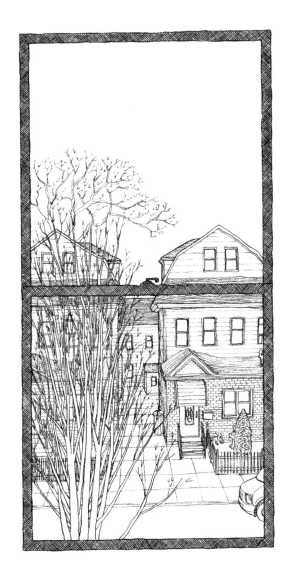

DEREK BERMEL

從我家所在的傑克森高地往窗外看，
我發覺建築物的立面比曼哈頓的平整得多，
至少在我看來是如此。
此地建築立面較少採巴洛克裝飾，
突出的飾物不多，
我只好去欣賞外觀上的細節，
端詳門框、模鑄的樓角或廉價的磚階有何微妙的差別。
這裡因為樓房沿街羅列開展而呈水平式景觀，
卻少了垂直視覺。
這裡沒有高樓大廈，
因此我的視線不常被打斷。
上街閒晃時，我會挨著建築物走。
很平整，每一棟都很平整。
最後我變成盯著磚塊與磚塊間的水泥猛瞧。
我想到馬塔-克拉克＊在七○年代收購畸零地皮的創作，
全都非常平整。
這裡的平整和寬廣想必給了他靈感。

When I look out the window in Jackson Heights, I notice the facades, flatter than their counterparts in Manhattan, or so they seem to me. The buildings here are less baroque. Their protuberances are fewer and I am forced to appreciate the details of the surface, to let my eyes linger on the nuances of a door frame or molding corner or cheap brick step. The horizontals are there, as the buildings spread out along the streets, but the verticals are missing. There are no tall buildings here. My vision is not so interrupted. When I stroll through the streets, I let my footsteps hug the buildings. Very flat, everything is very flat. I end up staring intensely at the cement between the bricks. I think of Matta-Clark's odd lots that he accumulated in the seventies, all of them very flat indeed. All this flatness and broadness must have inspired him.

＊ Gordon Matta-Clark，1943-1978，活躍於紐約的藝術家，最著名的系列作品「建築物切割」（Building cuts），
即是將廢棄的建築物切割為幾何形狀。七○年代，他收購紐約市政府為解決財政問題而拍賣的畸零地，展開
「實體所有權：不動產贗品」（Reality Properties: Fake Estates）計畫，打算運用攝影和錄像，創作前衛的城市地
景藝術，但生前並未完成此項計畫。

艾席卓・巴拉斯可 ｜ 視覺藝術家

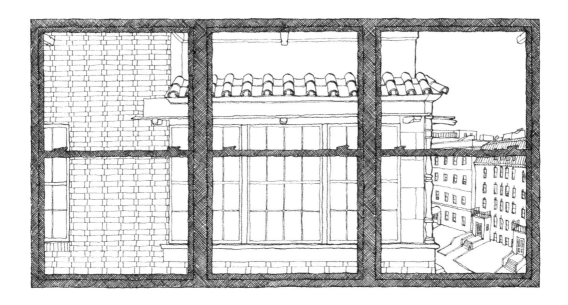

ISIDRO BLASCO

我的寫字檯斜對著窗口，
白天時把頭往左一偏就可以看見窗外。
我看到對街和我這棟樓並排、座落在二十一街上的公寓大樓。
那棟樓位於葛萊姆西公園北面，
房價顯然貴得要命。
它是一棟有寬大窗戶的漂亮磚砌樓房，
窗格外罩著較小巧、有如針織般的別緻鍛框。
我對面那層公寓裡有一台電漿電視，
大多數時候都是開著的，
我看得到它播放的任何電影或節目。
然而，最能代表我和從這張寫字檯往外看的時刻，
我想應該是像我現在提筆寫下這段文字的當下：
夜深了，對面的燈火已滅，我坐在這裡努力爬格子，
而當我轉頭看向這面窗，
只能看到桌燈映在玻璃上的光，
和我的臉孔模糊的輪廓。

My writing desk is kitty-corner to the window in this picture, and during the day, when I turn my head leftward and look outside, I'll see across the street, to the parallel apartment building on Twenty-first Street. That building is on the north side of Gramercy Park, and it's obviously expensive as hell to live over there, this beautiful brick jobber with large wide windows where the panes are crossed with a crochet of fancy-looking smaller frames. A lot of the time, a flat-screen plasma TV is on in the apartment across the way from mine and I can see whatever movie or program is playing. But the times that I think are most representative of me and my view from this desk are times like the very moment that I'm writing this—when it's the middle of the night, and the lights across the way are off, and as I sit here trying to figure out a paragraph, when I turn to the window, the only things I see are a reflection of light from my desk lamp and an outline, faintly, of my own face.

查爾斯・波克 ｜ 小說家

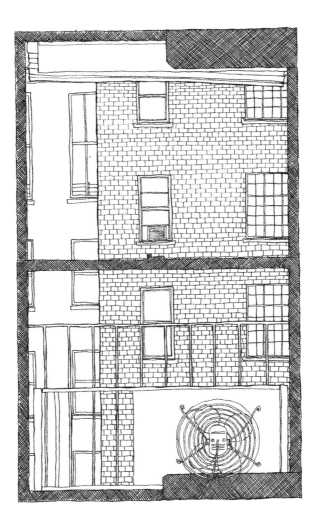

CHARLES BOCK

當我坐在桌前，
會非常在意那一大片天空。
在這三十四樓高的地方，
我聽不見地面的車聲，
倒是能看到天上的交通。
這扇窗子面東，
朝向拉瓜地亞機場和甘迺迪機場，
我通常每個禮拜都要從那裡飛進飛出。
這片天空把我帶到柏林、開羅、自由城和外頭的世界，
我工作時念茲在茲的地方。

When I sit at my desk, I'm very aware of the sky. From thirty-four floors up, I can't hear the traffic on the ground, but I can see the traffic in the air. My window faces east, toward LaGuardia and Kennedy, where I'm usually flying in or out every week. The sky links me to Berlin and Cairo and Freetown and the world out there. That's where my mind's at when I'm working.

卡蘿・波格特｜人權運動家

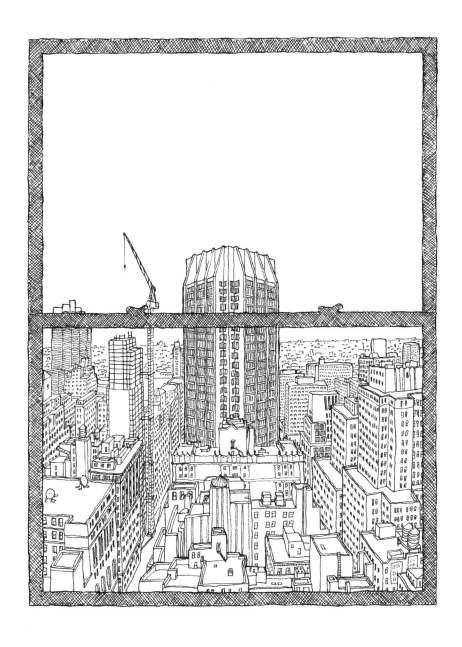

CARROLL BOGERT

我覺得我的窗景是紐約佬典型的窗景。
我們從自己的窗口望著別人的窗口，
並多少從中照見自己的生活——
我們經常彼此觀望，數百萬的我們，在街上或別的地方。
我有一對朋友就住在對街那些窗戶後頭，
但我大半時間還是把百葉窗拉開。
我們假裝不往外頭看，
所以照舊把簾子拉開，讓光線進來。
我住過風景更棒的地方。
有時候我會羨慕別人的窗景，
尤其現在到處蓋起了高樓豪宅，有成百上千戶，
每一戶的景都比我的還棒。
不過我覺得短期內這些樓宅多半會是空屋，
畢竟哪有人買得起啊？
說不定那些玻璃高樓會變成新的出租大樓，
便宜租給藝術家入住，
只是我看可能性不大。

I think of my view as pretty typical for a New Yorker. We look out our windows at other windows. That, in a way, mirrors our lives here—we are constantly looking at each other, millions of us, on the streets and elsewhere. I know a couple of the people behind those windows across my street, but I keep my blinds up most of the time anyway. We pretend not to look. This allows us to keep the blinds up and let some light in. I've been to places that have 'better' views. I sometimes have view envy, especially now as I see hundreds of luxury condos going up everywhere—all of them with better views than mine. I suspect that most of them will remain empty in the near future, as who can afford them any more? Maybe those glass towers will be the new homesteads—cheap artists' housing, but I doubt it.

大衛‧拜恩 ｜ 樂手、藝術家

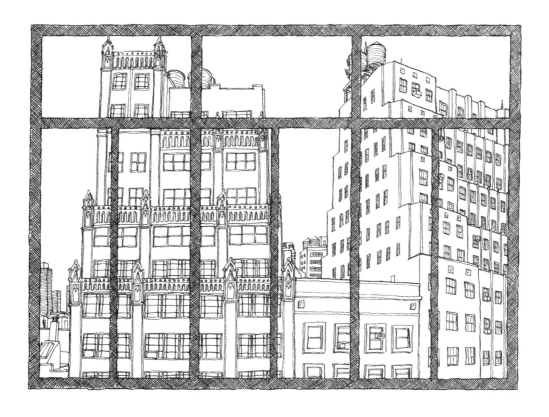

DAVID BYRNE

從書桌旁的這扇窗往外看，我可以看到已故之人。
譬如説，大名鼎鼎的馬戲大王巴納姆行經百老匯大道，
趕著張羅「大拇指湯姆將軍」*¹ 和「絕代女王」菈凡妮雅‧華倫的婚禮。
為她縫製嫁衣的戴摩芮斯夫人 *²，一八六三年就住我這戶隔壁。
也就是説，迷你的菈凡妮雅當年就站在我這面牆的另一邊。

看那窗外，女王陛下，
妳會看到我在二〇〇八年看到的同樣景象——八九不離十，夠接近了。
右邊那棟樓（妳只看得到它北面那片高高的牆面）本來是一家小劇院。
克利斯提的歌舞秀*³，一八四七年至一八五四年間，就在那裡演出。
黑臉、白臉相間的歌舞表演——願上帝保佑美國——距離我家大門只有三十秒的腳程。

劇院隔壁，木頭鳥的頭後面那一棟，是戴樂皮耶設計的。
它隔壁的高樓，當時還不存在。
我可以看到在它之前的樓房，也可以看到它被火舌吞噬。
我可以看到梅尼奇在一九〇二年為蕾絲織工設計的廠房。
就是這一棟，每層樓有五扇大窗。
這個有先見之明的設計還真是未卜先知，
二〇〇八年總統大選前那幾周，
對面鄰居裁出三呎高的字母，
正好填滿五格：O－B－A－M－A（歐巴馬）。

對一個寫作者來説，這樣的景很不賴，
看到人們開始想像過去沒人敢想像的事，
真不失為開展一天的好方法。

I can see dead people out this window, by my desk. For instance, the famous showman P. T. Barnum passes along Broadway, on his way to arrange the wedding of Tom Thumb to Lavinia Warren, the 'Queen of Beauty.' Mme. Demorest, who lived next door to me in 1863, would make the wedding dress. That is, in 1863 the tiny Lavinia Warren stood on the other side of my wall.

Peer over the window ledge, Your Majesty. You have the same view I will have in 2008, more or less, close enough. In truth, the building on the right in the drawing (you can just see its high northern wall) was a narrow theater. Christy's Minstrels played there from 1847 until 1854. Black and white minstrels—God Save America—thirty seconds walk from my front door.

The building next door, the one behind the head of that wooden bird, was by Bartholomew Delapierre. The building next to it did not exist. I can see the building that stood there before it. I can see the whole damn thing on fire. I can see Robert Maynicke's 1902 design for a loft for lace makers. That's it there, with exactly five huge windows on each floor. This farsighted plan meant that, in the weeks before the 2008 elections, our neighbors could cut out large three-foot-high letters to occupy the center of each frame. O-B-A-M-A.

It's a fine view for a writer, to see the unimaginable imagined, a good way to start the day.

彼得‧凱瑞｜作家

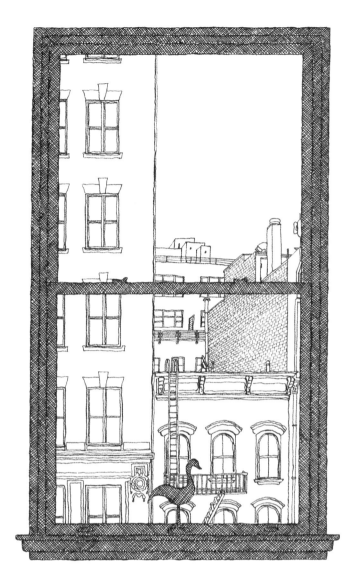

*1 本名查爾斯・史崔頓（Charles Stratton, 1838-1883），馬戲團裡紅極一時的侏儒，1863 年與同為侏儒的菈凡妮
雅・華倫（1841-1919）結婚。兩人堪稱 1860 年代最知名的公眾人物，連總統林肯都曾在白宮招待過他們。
*2 美國女商人，原名 Ellen Louise Curtis（1825-1898），本來開設一家婦女頭飾用品店，與戴摩芮斯結婚後在紐約
開了一家時裝店，丈夫開始出版《戴摩芮斯夫人時裝鏡》（Madame Demorest's Mirror of Fashions）季刊，隨雜誌
附贈一份服裝打版紙樣。在夫妻倆的成功經營下，時裝店與雜誌皆廣受歡迎。
*3 Christy's Minstrel 是知名民謠歌手克利斯提（Edwin Pearce Christy, 1815-1862）組成的歌舞團體。Minstrel 係指
19 世紀美國蓄奴時期，由白人把臉塗黑扮成黑人的歌舞藝人，劇中的黑人多半是丑角。

PETER CAREY

坐在我的辦公椅上看去的景象，
很像文字被刪除鍵——消去、只剩通篇工整空格的頁面，
而且彷彿無止無盡。
但若我把椅子朝右一轉，
這間位在康泰納士大樓東南角、時報廣場西側上方二十二層樓高的辦公室，
窗外的全景甚至更壯觀。
我可以看見東河緩緩流過四十二街街谷的盡頭，
天氣格外清朗時，
還可以一路望見皇后區的根翠茵廣場州立公園。
往南邊看，
赫爾姆與柯柏特設計的哥德式布許大樓頂端精緻的塔冠，聳立在眼前；
往北邊瞧，
新落成的美國銀行大樓，其以玻璃和鋼材打造、宛如艾雪錯視畫般的斜切面，
映照出周遭建築物的倒影——
直到夜幕低垂，
大樓的玻璃帷幕消融在夜色裡，
顯現出大樓內部銀行員工汲汲營營的忙碌景象。
在這驚人的大都會構圖之間，
紐約市立圖書館後方的布萊恩公園，
孕育著一小片方整的樹林。
它龐大的樹蓬在四季更迭中敏捷地搖擺，
顯然以逗弄圖書館具純藝術風格的佛蒙特大理石樓面為樂。
「恆心」和「毅力」這一對石獅，
堅定地盤坐在圖書館的第五大道入口兩側，
和我一樣寧可望向東方。

The view from my office chair is typically filled with fields of Times New Roman type receding in evenly spaced rows. They seem to go on forever. But if I turn my chair to the right, the panorama outside my office, which occupies the southeast corner of the Condé Nast Building twenty-two floors above Times Square to the west, is even more spectacular. At the far end of the Forty-second Street canyon I can see the East River flowing by and—on particularly clear days—all the way to Gantry Plaza State Park in Queens. To the south, the exquisite crown atop Helmle & Corbett's Gothic Bush Tower soars at eye level. To the north, the newly finished Bank of America Tower—with its Escher-like slopes of glass and steel—reflects its neighbors until nightfall, when the building's exterior dissolves to reveal a glowing hive of bank employees updating their résumés. Between this striking urban frame, Bryant Park, to the back of the New York Public Library, is home to a neatly boxed grove of trees. And its great canopy moves swiftly through the seasons to the apparent amusement of the library's Vermont-marble Beaux-Arts facade. 'Patience' and 'Fortitude'—as the building's pair of unflinching stone lions flanking the Fifth Avenue entrance are called—would rather, like me, look to the east.

葛雷登・卡特 | 雜誌總編輯

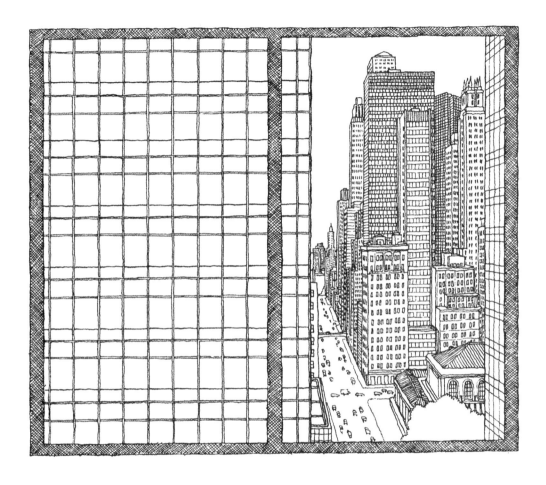

GRAYDON CARTER

我在雀爾喜區看了許多赤褐砂石打造的高級住宅，

才找到這間屋子，

它的起居室地板少見地完整保留了原始鑲飾版。

這是一大賣點，但不足以讓我當場買下來。

不過，一看到主臥房的這個窗景，我的心融化了。

我們家西南方，

帝國大廈的尖頂從高層樓房景致後方探出頭窺視著，

而雀爾喜飯店南側現身在我們對街赤褐砂石建築後頭。

這片景色道盡了我所熱愛的紐約。

我愛看帝國大廈頂端天天變化的彩光，

其柔和的光色為我的臥房增添了無限浪漫。

外子和我有相熟的朋友就住在雀爾喜飯店，

他們可以從窗口看見我們的臥房。

每次去拜訪他們，我都會從他們家往我們家的窗口望，

看看從外頭望過來是什麼景象。

I looked at a lot of brownstones in Chelsea before we found this one, and it was one of the few that had the original moldings still intact on the parlor floor. That was a huge selling point, but it wasn't enough to seal the deal for me. This view, from the master bedroom window, made my heart melt. The top of the Empire State Building peeking over the high-rise landscape from our southwest perspective, with the south side of the Chelsea Hotel rising in back of the brownstones across the street, spoke to me of everything I love about New York. I love to see the changing colors on the top of the Empire State Building, and the soft hues add a lot of romance to our room. My husband and I have close friends who live in the Chelsea Hotel, and they can look out their window and see our bedroom. Whenever I visit them, I can look at my own window from their apartment and see the reverse of my view."

蘇珊・凱許 ｜ 創作樂手、作家

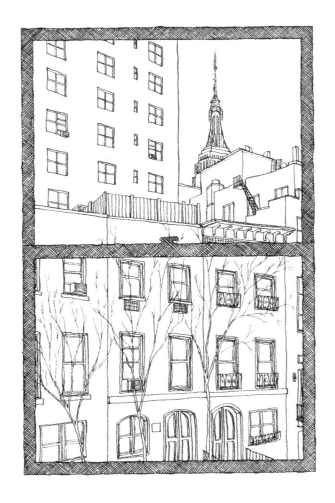

ROSANNE CASH

因為我的套房正對著一棟沒有窗戶的電信大樓，
樓頂架設了好幾座基地台，
導致每次想到我家的窗景，
大多會想到癌症，
所以我努力讓自己根本不去想窗景這種事。

Because my studio is directly across from a windowless telecommunications skyscraper whose peak bristles with microwave transmitters, when I think of my view mostly I think about cancer, so I try not to think about it at all.

史蒂芬・寇柏特｜喜劇演員、電視節目主持人

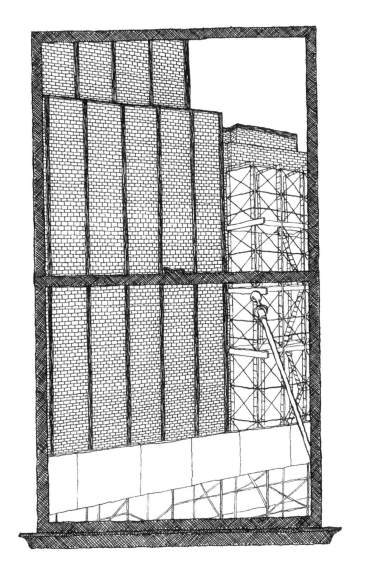

STEPHEN COLBERT

工作時我會摘下近視眼鏡，戴上閱讀用眼鏡，
所以窗外看上去通常是朦朦朧朧的。
這樣很好，我可不想分心。
但我還是喜歡看窗景，
因為它提醒我正身在何處——
就目前來說，是布魯克林「公園斜坡」的南區。
這扇窗面南，
而我們這一區的樓房都不高，
所以只要有陽光，就整天都照得到太陽。
我不像畫家那樣對光線敏感。
我喜歡陽光直接打在我身上。
畫中的長梯是拿來綁曬衣繩的塔柱，
當中有些看來和樓房一樣老舊，
打從上世紀之交就在那裡了。
閒來沒事時我會想，
要是我們的梯子還夠堅固，
說不定彼得和我也該從善如流，用這種老方法晾衣服。

I wear my reading glasses while I work, not my distance glasses, so the world I see through this window is usually fuzzy. That's ideal. I don't want to be distracted, but I like the reminder that I'm located somewhere particular—in this case, southern Park Slope, Brooklyn. The window faces south, and since all the buildings in our neighborhood are low to the ground, it gets sun all day, when there is any. Unlike painters, I'm not subtle about sunlight. I like it to hit me directly. The ladders in the picture are towers for attaching the far ends of laundry lines. Some look as old as the buildings, which date from the turn of the last century. In idle moments, I wonder if ours is still sturdy enough to climb, should Peter and I ever decide to dry our clothes the old-fashioned way.

克列柏‧克雷恩｜作家

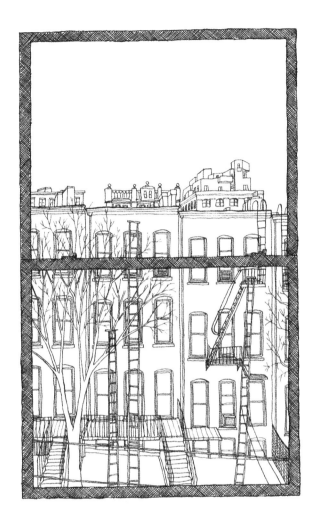

CALEB CRAIN

我很少有機會為文評論建築，
但啟蒙我如何評析藝術的，是維特考爾論建築的文章。
事實上，我剛開始評論藝術的文章之一，
談的就是我家窗前的這一棟建築。
我對它有十二層樓高度（我們家這一棟也是），
以及「純藝術」傳統出身的建築師如何設計出這種高度的建築物，很感興趣。
這種高度的建築在二十世紀初的需求量很高，
而拜地鐵將電力系統帶入這一帶所賜，
使當時的電梯得以升到那個高度。
我覺得很有意思的是，
這棟樓是從羅馬的法爾尼榭宮變化而來的——
瞧它主要樓層的鄉間風格與裝飾物就知道了。
主要樓層以上，建體「咻」地拔高約九層樓，
樓頂是另一種義式風格的結構。
那年代的建築物是房地產、電力和「純藝術」建築價值共同孕育的產物。
這棟樓的立面和路緣之間美妙地留了幾步距離，
因此並未擋住我們望向公園的視野。
而我們住的樓層夠低，
足以感染街上來來往往的狗、學童、計程車和滑板手散發的活力。

I rarely get a chance to write about architecture, but it was through the architectural writings of Rudolf Wittkower that I first learned how to think about art. Actually, one of the first pieces I ever wrote on art was about the building seen through our window. I was interested in the fact that it is twelve stories high, like our building, and that the architect, trained in the Beaux-Arts tradition, had to figure out how to design a building that tall. There was a demand for buildings of this height early in the twentieth century, and it was now possible to lift elevators that high because the subway had brought power lines up to this neighborhood. I loved the fact that the building is a variation of the Palazzo Farnese in Rome—notice the rustication and the ornamentation of the piano nobile. Then zip! the body of the building is about nine stories high. At the top, there is another Italianate structure. All the buildings of that era are a product of real estate, electricity, and Beaux-Arts architectural values. The building is nicely set back, so it does not block our view of the park. We are just low enough to take in the street life: dogs, schoolchildren, taxis, skateboarders."

亞瑟‧丹托｜哲學家、藝評家

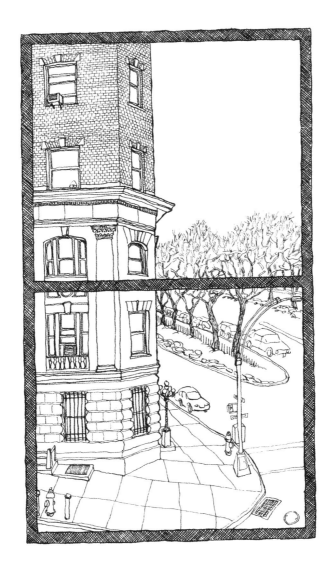

ARTHUR DANTO

布魯克林的這間公寓，我一租就租了十年，
在我朋友圈裡堪稱一項紀錄，
而且我一直拿臥房兼辦公室用。
這是從我的桌前看出去的風景。
每當我想偷抽菸解解癮時，就會靠著這扇窗探出身去。
我從不放下百葉窗。
這棵樹夏天給我一些隱私，入冬就收回。
年輕時住過的印第安納州老家，
窗外除了風雨聲，便是一片寂靜。
在這裡，
我可以聽到小孩子在右手邊圍欄內的遊樂場嬉戲，
低沉嗡鳴的車輛聲從那些樓房另一頭的某處傳來，
還有鄰居傍晚在院子裡喝啤酒作樂。
我聞到烤肉、爐灶和垃圾的氣味。
順道一提，這棵樹是臭椿，
《布魯克林有棵樹》書裡那種樹。
從屋前起居室的窗口，
我目睹了這個街區的轉變。
但眼前這個火警逃生露台、通往屋頂的逃生梯和那棵樹——
屬於我的布魯克林一隅，
始終沒變。

Ten years renting the same Brooklyn apartment—a record among my peers—
and I still have a bedroom/office. This is the view from my desk. It's the window
I lean out of when I sneak cigarettes. I never lower the blinds. In the summer,
the tree offers privacy, and as winter comes, I lose it. The windows of my
Indiana youth were quiet except for weather. Here, I can hear kids playing on
the caged playground deck to the right, traffic humming somewhere on the
other side of those buildings, my neighbors drinking beer in their gardens at
dusk. I smell barbecues and fireplaces and trucks. That's an ailanthus tree, by the
way, the Tree Grows in Brooklyn tree. Through my living room windows, in the
front of the house, I've seen the neighborhood change. But this fire escape
patio, these stairs to the roof, that tree: my own piece of Brooklyn has stayed
the same.

麥特・戴林傑 ｜ 作家、新聞工作者

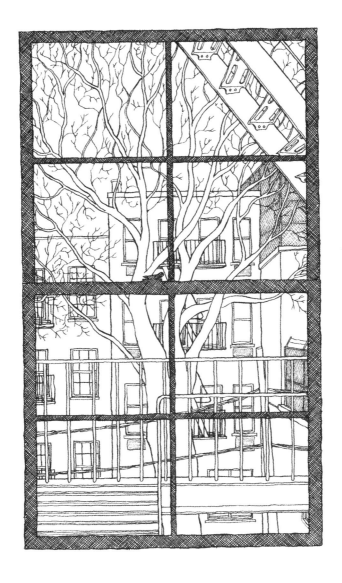

MATT DELLINGER

在這麼高的地方，窗子不再是窗子，
反倒像窺視孔。
這是如假包換的「後窗」，
獨不見美侖美奐的房子，
也不見人性光輝。

Up here windows are not windows; they're more like peepholes. Rear Window without any of the architectural or human splendor.

朱諾・迪亞茲｜作家

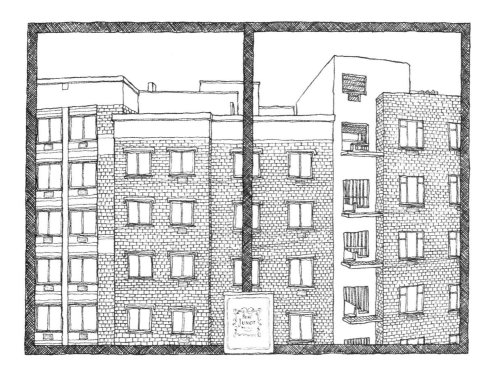

JUNOT DÍAZ

我這面窗景頗具考古風情：

較靠近地面的那些樓房，興建於二〇、三〇年代；

接著，比較高一些也寬大得多的大樓，是大戰後一片榮景的例證；

最遠處則是建於二十世紀末與二十一世紀初、直聳雲霄又不可一世的摩天樓。

這片城景，徹底失序之餘，又詭祕地融合為一氣。

而航行在空中軌道上的羅斯福島纜車，

隔著距離從我這裡看去，宛如遊樂園裡孩童開的玩具車。

不過，我最感激的，

是這面景仍保有一大片天空。

This is my archaeological view, the buildings closer to the ground dating from the twenties and thirties, then the loftier bulkier examples of the postwar boom, and finally the arrogant sky-poking towers of the late twentieth and early twenty-first centuries. A totally chaotic cityscape, mysteriously coherent. And sailing through its alleys of air is the Roosevelt Island tram, which from this distance seems like a children's ride over a fairground. But what I'm most thankful for is the expanse of still available sky.

E.L.達克多羅｜小說家

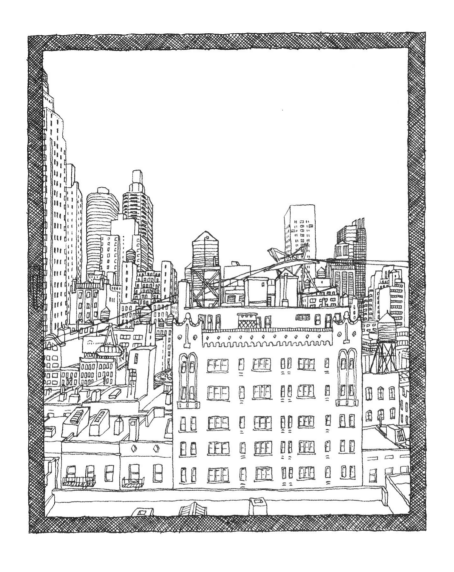

E. L. DOCTOROW

光有這片天空我就很滿意，
而我一直非常珍視它。
從這扇窗，
你可以看到帝國大廈的尖端，還有克萊斯勒大樓的頂端，
而且它們入夜後都會散發出美麗的光芒。
這些年來我發現，
從這裡可以看到中央公園夏日釋放的煙火，
不過只有在接近尾聲時才看得到，
因為只有壓軸的煙花飛得夠高，
足以照亮鄰近大樓的上空。
我最愛的紐約特色（也是我最著迷的東西之一），
就是木製水塔。
每個屋頂上都有一座，
從這窗口看去就有好幾個。
我剛搬到城裡來時，
有位朋友把它們當稀世珍寶似地指給我看。
他對它們簡直稱得上迷戀。
我不曉得假使他沒提醒我，我會不會注意到這些水塔，
說不定我也會把它們當成某種奇觀。
不管怎麼說，我早就和他沆瀣一氣了。
而今我可不願拿它們來交換遠方的山景。
在我眼裡，它們已然是這座城市的化身。

I'm just happy to see sky. I really never take it for granted. From that window, you can see the tip of the Empire State, and the peak of the Chrysler Building, both of which light up beautifully at night. Over the years, I've learned you can catch the fireworks in Central Park during the summer, but only ever the finales—those are the only shells they fire high enough to clear the buildings nearby. My favorite New York feature, one of the things I'm most attached to, is the wooden water tower. There's one on every roof. And I look out on a bunch. When I first moved to the city, a friend pointed them out as things of great majesty. He was obsessed with them. I'm not sure I would have noticed the water towers without help, or that I'd have decided they were some kind of wonder. But I've long since come to agree. Now I wouldn't trade them for mountains in the distance. They are very much this city to me.

納森・英格蘭德｜作家

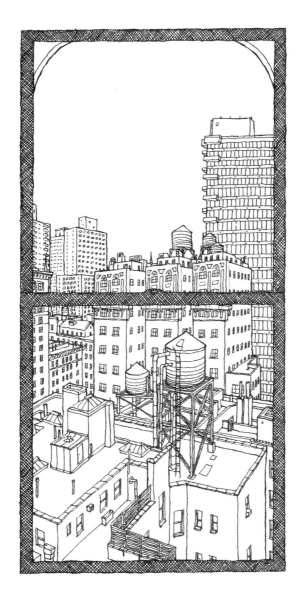

NATHAN ENGLANDER

從我辦公室這座美麗的落地窗台望出去，
可以看到克萊斯勒大樓。
它是全世界我最喜歡的一棟建築，
是我對紐約懷抱的每一個閃閃發亮夢想的完全縮影。
幸好我寫作時是背對著它，
否則會半個字也寫不出來。

One of the things I can see through these beautiful Juliet windows in my office is the Chrysler Building. It's my favorite building in all the world, the absolute epitome of every glittery dream I have ever had about New York. Fortunately, when I write, I face away from it, or I would never get anything done.

諾拉‧伊佛朗｜導演、作家

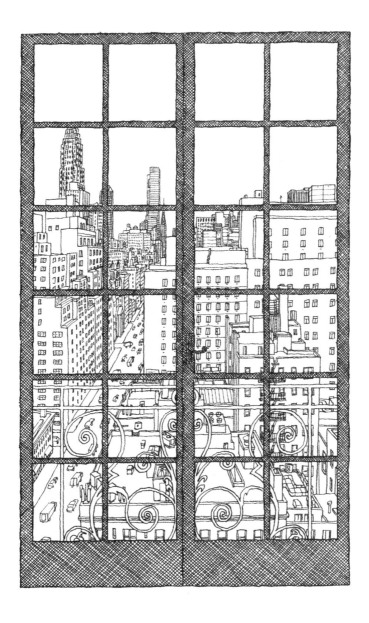

NORA EPHRON

我喜歡這窗景顯露的嚴苛無情，
喜歡看對面那棟精神病院的翼樓。

I like the grimness of it, like seeing the other wing of the madhouse across the alley.

李察‧伏洛德｜新當代藝術館博物館館長

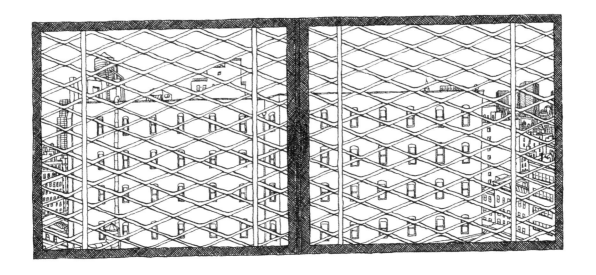

RICHARD FLOOD

鮮為人知的建築師史帝芬‧狄卡特‧黑屈設計了對街這棟傑作。

我很幸運，可以透過我的窗口天天欣賞它。

有時候我會想像自己是住在遙遠的地方，

某個北歐城市，或是古代城堡。

我常在想，

對面的居民看不到我眼前的景致，真是一種損失。

他們只能盯著瞧我這棟和附近幾棟相形之下很不起眼的樓房。

眼睛從來看不見自身。

這有時說來是一種福氣，

有時則不盡然。

Little-known architect Stephen Decatur Hatch designed a masterpiece across the street from me. I am lucky to gaze at it every day through my window. Sometimes I imagine that I am living someplace far away, a city in northern Europe or in a castle during another time. I often think about the loss the inhabitants across the street must feel because they cannot see what I see. They are stuck looking at my rather undistinguished building and the others surrounding it. The eye can never see itself. Sometimes that is a lucky thing and sometimes not.

奈爾‧法蘭科｜藝術家

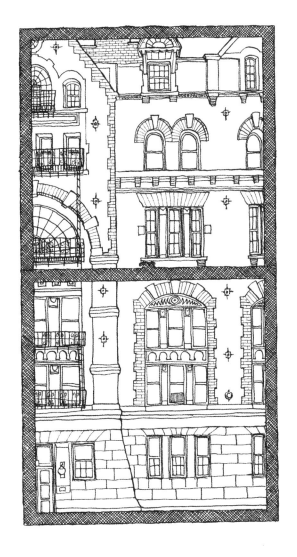

NIEL FRANKEL

垃圾車每天清晨三點半或四點就會把我吵醒，毫無例外。
要是窗戶是開著的，
垃圾的味道就會飄進來——噁！
真是紐約髒亂面的寫真。

The garbage truck wakes you at 3:30 or 4:00 every morning without fail. If you open the window, the smell of garbage—yuck! The true picture of a mess in New York.

格勒克仁波切｜藏傳佛教大師、流亡作家

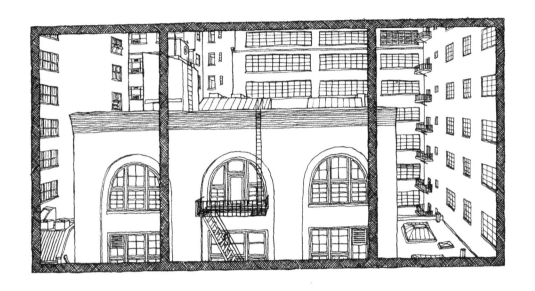

GELEK RIMPOCHE

我剛搬來這個工作室時，
有木板片封住這扇窗。
拆掉木板、讓這扇窗重見天日後，
我發現這裡的窗景十足展現了下曼哈頓的奇妙風情。
從一七六〇年代的荷蘭教堂到最摩登的大樓，
它包含了超過兩世紀的建築物，
而我近來開始將之畫到我的作品裡。
在我眼裡，
這個景代表無窮的活力與希望，
紐約生活的最佳寫照。

When I first moved to this studio, the window was covered with boards. As I removed them and replaced the window, I realized what a marvelous, comprehensive view this is of Lower Manhattan. From the 1760s Dutch church to the most modern buildings, it contains more than two centuries of architecture, images of which I've recently started to use in my paintings. It represents to me the endless activity and hopefulness that is life here in New York City.

尼克・吉斯｜藝術家

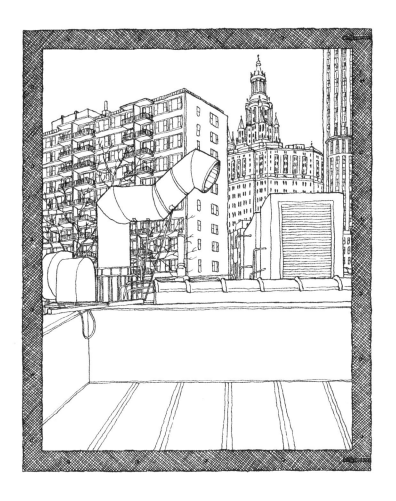

NICK GHIZ

水塔、冷氣機、排氣管。
紐約的基礎設施盡收眼底。
我愛死了！

Water tanks, air-conditioning, and exhaust pipes. The infrastructure of New
York in plain view. I love it!

菲利普・葛拉斯｜作曲家

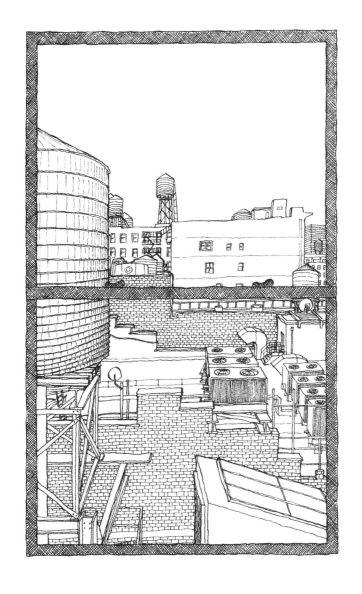

PHILIP GLASS

從我桌前看出去的這片風景，
透露出我不在市中心的事實。
這裡看得到一小段東河，
河的另一端是聯合廣場，以及一大片天空。
這一帶就像九〇年代的市郊那樣寧靜。
有個老先生在前一棟的樓頂上搭了鴿籠養鴿子。
而今，整個視野愈來愈小——
河邊陸續蓋起了高樓，
前方兩棟樓以外的低矮房子也加蓋了幾層，
遮住大半的河景。
就連原有的寧靜也消失了：
白天有蓋房子的施工聲，
方圓一條街區內開了六家夜店（酒吧、夜總會、啤酒廣場）。
城市的嘈雜又追上我了。

The view from my desk shows my remove from the heart of the city. There's a sliver of the East River visible, Union Square beyond, and lots of sky. This corner was quiet like the suburbs in the nineties. An old man kept his pigeons in a coop on the roof next door. Now the view is shrinking, with high-rises going up along the river, and the low building two doors down adding a few floors and blocking out most of the river view. And the quiet is gone—construction during the day and half a dozen night spots (bars, music clubs, a beer hall) in a one-block radius. The city chased me down.

伊森・荷遜菲德｜聲樂家

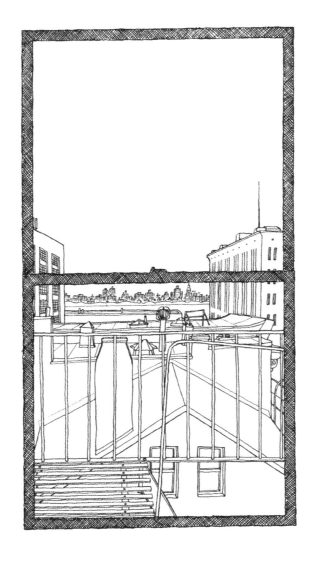

ETHAN HERSCHENFELD

我 的 窗 可 以 讓 陽 光 通 行 無 阻 地 灑 進 來。

My window view allows the light to shine through unimpeded.

郭德華 ｜ 前紐約市長

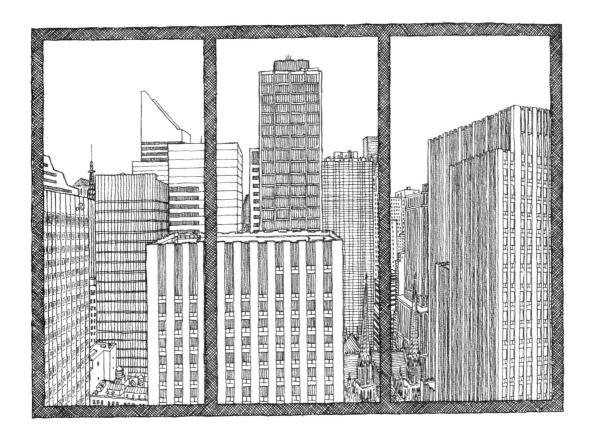

ED KOCH

我兒子的臥房面向布魯克林倫理文化協會。
整個夏天，協會的人把花園租給民眾辦婚禮：
銅管樂隊演奏、醉醺醺的敬酒、答禮，
《今晚，你感受到愛了嗎？》、《這就是愛！》，
以及《奔放的旋律》等歌曲滲入他的睡夢裡。
好一場受陳腔濫調的浪漫薰陶之童年教育。

My son's bedroom looks out over the Brooklyn Society for Ethical Culture. All summer, the Ethicists rent out the garden for weddings: brass bands, drunken toasts, feedback, Can You Feel the Love Tonight, That's Amore, Unchained Melody filter through his sleep. A child's education in romantic cliché.

妮可‧克勞斯｜作家

NICOLE KRAUSS

我住過可以看到一小截哈德遜河的公寓。

那景色真是壯麗，可惜後來我搬走了。

我們現在住的公寓，是我生平住過最高的樓層。

我成了高樓不勝寒一族。

我沒料到自己會犯暈眩，

然而這個高度，

我這片峭壁和周遭峭壁之間的街谷，

真的讓我頭昏眼花、腳底發涼。

我想，真正喜歡曼哈頓的人，

一定會在當中找到機械式的情色意味：

網格、曲線、歐式幾何、直角銳角；

這些線條，以及這些關乎力量、對稱與野心的無機排列設計，

是如何切割、纏扭與圍捕那些有機、不對稱、鬆散的東西；

它們鬆散又柔弱掙扎著，既歡愉又痛苦地

被禁錮在這些檻檻之後，被綑綁在這些框架之內。

這有點像虐待狂和受虐狂。

但我還是想念河景。

I once had an apartment with a narrow view of the Hudson, and that was really splendid, but I moved. Our current apartment's higher up than any place I've ever lived; I've become a cliff dweller. I never thought I had vertigo but the altitude, the vast canyon spaces between my cliff and neighboring cliffs give me a peculiar, heady, woozy thrill. I assume anyone who really loves Manhattan must find engineering erotic: grids, graphs, Euclidean geometry, right and acute angles; the way these lines, these inorganic arrangements of force, symmetry, and ambition slice and tussle with and trap the organic, the asymmetrical, the sloppy; the way the sloppy and soft struggle, joyfully and miserably, caged behind these bars, girdled within these frames. It's kind of S&M. But I miss the river.

東尼‧庫許納 ｜ 劇作家

TONY KUSHNER

剛住進這間位於格林威治村的屋子時，
我以為住在一樓，不會有景可以看。
後來我發現，在每天的某個時刻，
後面那個小庭院另一頭的磚牆上會有個影子慢慢成形。
我可以透過餐廳的玻璃門看到它。
那是我們院子裡一棵大無花果樹投影在牆上的印記。
借來的風景。
紐約獨有的。

When I first began living in my house in Greenwich Village, I thought I had no view on the ground floor. And then I noticed that at a certain time of day, a shadow slowly forms on the brick wall at the far side of the little yard in back. I can see it through the glass doors in the dining room. The imprint of a large sycamore tree growing in our yard takes shape on the wall. It's a borrowed view. A New York thing.

安妮‧萊博維茨 ｜ 攝影家

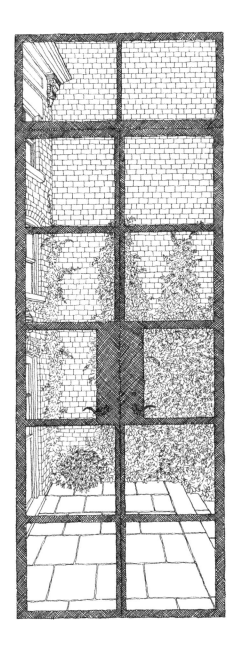

ANNIE LEIBOVITZ

我窗前這片景捕捉到紐約的詩意。
它飽含感情和幾何線條……而感情才是建築的靈魂。
好一座讓人激動的回憶劇場！

The view from my window captures the poetry of New York. It is full of emotion and geometry … and yet it is emotion which is at the core of architecture .What an inspiring theater of memory!

丹尼爾・李伯斯金｜建築師

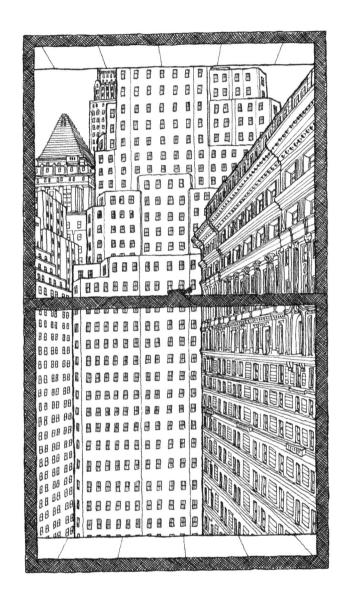

DANIEL LIBESKIND

我的書房位在一棟赤褐砂石樓房的三樓（頂樓），
過去十四年來，我和妻女一直住在這裡。
夏天往窗外看去，
我看到幾棵老樹交織出一片生氣盎然的綠意。
秋天時葉子枯黃掉落，
才能把對街的赤褐砂石樓房看得更清楚。
我從來不用窗簾或百葉窗，
也不確定對面鄰居能看進我們屋內多少，
所以我在書桌前寫稿時從不（或很少）打赤膊。
我們這一區位於凱羅花園，相當幽靜，
居民曾經有九成是義大利人，如今比較多元化了。
我很高興這面景色頗平凡無奇，不會美得讓人屏息，
因為如詩如畫的風景會讓我無法專心寫作。
有句古話說沉思就像「待在褐色的書房裡」，
而正對著對街濁泥般的暗褐色樓面與門廊形成的景幕，
確實能讓我好好沉浸在自己的思緒裡，
只隱約意識到這布魯克林特有的氛圍——
急駛而過的車聲、樹葉的窸窣聲。
我感覺彷彿繭居在自己的樹屋裡，
窗外景致柔和的色澤在邊緣處有點朦朧，
宛如一幅柯洛的畫作。
窗子的兩側擺著書櫃，
其他作家的書背突出書櫃，
從眼角餘光瞥去，
就像尖錐刺股一般驅策我努力不怠。

My writing office is on the third (top) floor of a brownstone where my wife, daughter, and I have lived for the past fourteen years. When I look out the window in summertime I am aware of a generalized green from several old trees; in autumn the leaves turn brown and fall off, and I can see much more clearly my neighbors' brownstones across the street. I've never put up curtains or window shades, and I am never sure how much my neighbors can see into my room, which is why I don't write at my desk in the nude (or not very often). Our block, which is in Carroll Gardens, is a quiet one and used to be 90 percent Italian, but now is more mixed-gentrified. I am glad the view is fairly mundane and not more breathtaking, as a vista too picturesque might distract me from my writing. The old expression for meditating is being in "a brown study," and the muddy cocoa backdrop of brownstone facades and stoops across the way permits me to stay in my thoughts, while I am dimly conscious of the lapping ambiance of Brooklyn, the sounds of passing cars and the twittering leaves. It is as though I were cocooned in a tree house of my own. The muted colors outside my window are slightly blurred at the edges, like a Corot painting. On either side of my central window are bookshelves, and the spines of volumes by other authors, peripherally glimpsed, act as prods to keep me at the task.

菲力普・洛佩特 ｜ 作家

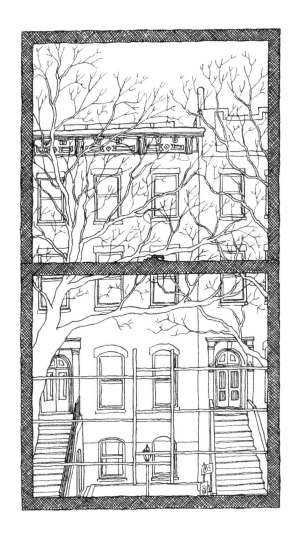

PHILLIP LOPATE

我 的 窗 景 是 由 嵌 有 極 細 白 色 線 條 的 窗 玻 璃 接 合 而 成 的 ，
使 它 彷 彿 罩 上 一 層 近 乎 透 明 的 紗 ，
外 頭 下 方 的 博 物 館 花 園 和 對 街 大 樓 輪 廓 ，
因 此 顯 得 柔 美 許 多 。

My view is tempered by windows fritted with fine white lines, creating an almost diaphanous veil that softens the outlines of the museum's garden below me, and the apartment buildings across the street.

.

格 倫 ‧ 勞 瑞 ｜ 紐 約 現 代 美 術 館 館 長

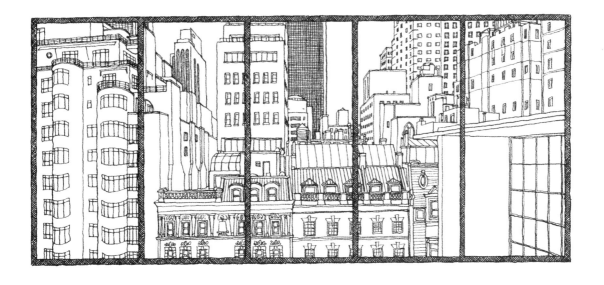

GLENN D. LOWRY

我們是城市人，
城市生活對我們很重要。
話雖如此，
可以看到樹木和幽靜的庭院，
以及欣賞隨季節變化的窗景，
諸如秋天的繽紛斑斕、歲末的節慶燈火與春天的花苞嫩芽，
讓我們在繃緊神經的都會生活之餘也能得到放鬆。
最重要的是，
這個窗景有陽光，
大量的陽光。

We are urban folks; city life means much to us. However, having a view of trees
and a serene courtyard where we can enjoy the changing views that come with
the seasons—the colors of fall, the lights of the holidays, the buds of spring—
provides a relaxing contrast to the energy of the city. Most important, this view
comes with light; lots of light.

弗列德・魯布林｜神經學家

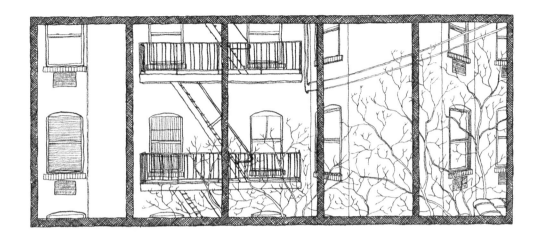

FRED LUBLIN

夕陽橘艷艷地在右下窗格另一頭的地方沉落，
將一切暈染成金紅色，
閃閃生輝。

The sun sets orange beyond that lower right pane and everything is golden and aglow.

溫頓・馬沙利斯｜爵士樂手、作曲家

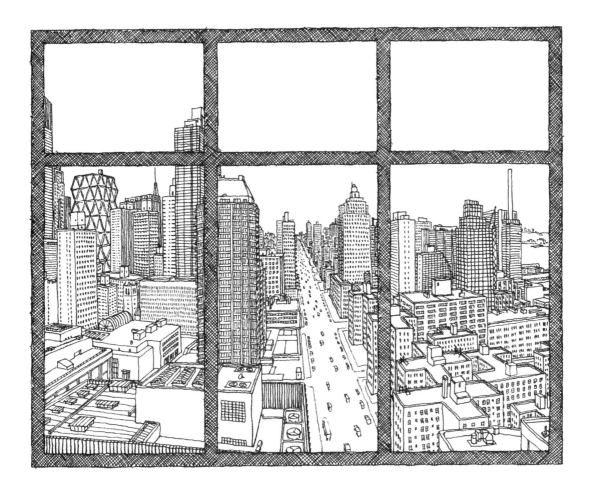

WYNTON MARSALIS

二十八年來，這片風景天天和我打照面。
它分成兩半，
左半邊是對街一棟建於一九〇九年的公寓大樓南面，
灰撲撲的磚牆很不起眼，
而且它一排排一模一樣的窗戶，總是緊閉著窗簾，成天空茫地望著我。
說來其實沒什麼看頭。
右半邊的景分成上下兩半，相形之下堪稱視覺的饗宴：
上面是瞬息萬變的天空，
下面則是一片勾勒出中央公園所在的樹海。
你可以遠眺城東，
但那一帶太過北邊，已經越過曼哈頓知名的天際線，
因此只能看到西奈山醫院那棟醜陋又矮胖的褐色建築佇立在遠方。
醫院後方那綿延一百二十度的背景裡，
可以看見零星幾棟位於九十六街北面的高樓頂端。
白天裡幾乎看不見、入夜後串成一條不時在移動且紅白相間的項鍊，
其實是不斷進出拉瓜迪亞機場的飛機。
要是我把窗子打開，又剛好吹東風，
則飛機起飛時的引擎加速轟隆聲聽起來吵得嚇死人，彷彿近在耳畔。
頭頂上終日往返紐澤西的通勤直昇機也不遑多讓。
貨車、公車、救護車、警車、消防車、摩托車
以及開窗強力放送嘻哈歌曲的休旅車，
在中央公園西側大道上不分晝夜南來北往地呼嘯而過。
二十八年後的今天，我已經不太察覺到這些風景和噪音的存在，
跟住在克里夫蘭沒什麼兩樣。

This view has greeted me every day for twenty-eight years. It's sliced in half. The left half is a vertical slab of the south side of the undistinguished grayish brick 1909 apartment building across the street, its rows of identical windows staring blankly back at me because the blinds and curtains seem to always be drawn shut. It gives the eye no nourishment whatsoever. The right half of my view is horizontally sliced in half and offers a visual feast: ever-changing sky above, the screen of trees bordering Central Park below. You can see far to the east, where it's too far north for a glimpse of real Manhattan skyline except for the ugly brown stub of Mount Sinai Hospital poking up in the distance. Behind and beyond is a 120-degree background sweep taking in the tops of the few tall buildings that stand north of Ninety-sixth Street. Barely noticeable in daytime but forming a constant moving necklace of tiny red and white lights at night is the traffic coming into and flying out of LaGuardia Airport; when my window is open and the wind blows from the east, the roar and whine of jet engines accelerating for takeoff sounds frighteningly loud and close. So do the commuter helicopters overhead, shuttling all day to and from New Jersey. Trucks, buses, ambulances, police cars, fire trucks, motorcycles, and SUVs with open windows blasting hip-hop race up and down Central Park West twenty-four hours a day. These views and these noises barely enter my consciousness today, after twenty-eight years. I might as well be in Cleveland.

布魯斯・麥考│插畫家、幽默大師

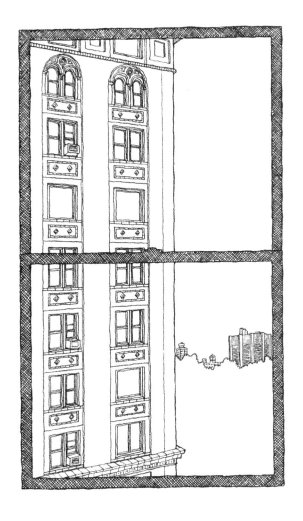

BRUCE MCCALL

當我們從窗口看出去，

眼中所見都不盡然相同。

我們必須以看待故事的角度來看待自己的窗景。

我總以為：

我們開多少次窗，就可以編織出多少個不同的故事。

所以我的窗外可以是塞拉耶佛、舊金山、雪梨、聖彼得堡，

以及都柏林（我這輩子頭一回開窗時看到的地方）。

然後，當然還有紐約——

我現在天天開窗凝望的地方。

窗一開，心就往外飛出去。

我們很可能面對著一面磚牆、一個空調出風口，

或一道鑄鐵雕花柵欄，

然後從中發現一連串奧祕。

我記得有一回，

一隻鳥飛進我的房裡，

一頭往我牆上掛的幾幅畫撞上去，

最後從牠飛進來的窗子飛出去。

What we see out our windows is not always what others see. We must treat our windows like stories. I like to think that we can open them up to as many other stories as we want. So outside my window is Sarajevo, and San Francisco, and Sydney, and Saint Petersburg, and Dublin where I first opened a window, and of course New York, where I continue to open windows. The mind leaps outward. We may look at a brick wall, or an air-conditioning vent, or a patch-work of iron bars, and find in them a series of mysteries. Once, I recall, a bird flew into my room. He bashed himself against the paintings that I had on the wall. He got out through the same window he came in.

科倫・麥肯｜作家

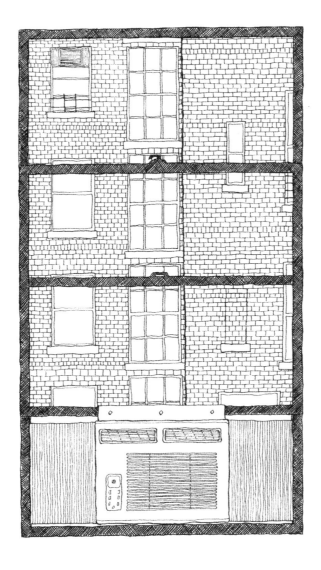

COLUM MCCANN

我的辦公室面東，朝向帝國大廈，
窗櫺是房東最近剛換上的，
因為他想為這棟樓的窗戶添一點現代感。
可惜他下手過重，
所幸入夜後窗外景致璀璨如昔。

The mullions on this window in my office—which looks east to the Empire State Building—were recently changed by the landlord who wanted to 'modernize' the windows of the building. It was a heavy-handed gesture, but at night the view is still as glorious as ever.

李察‧麥爾 | 建築師

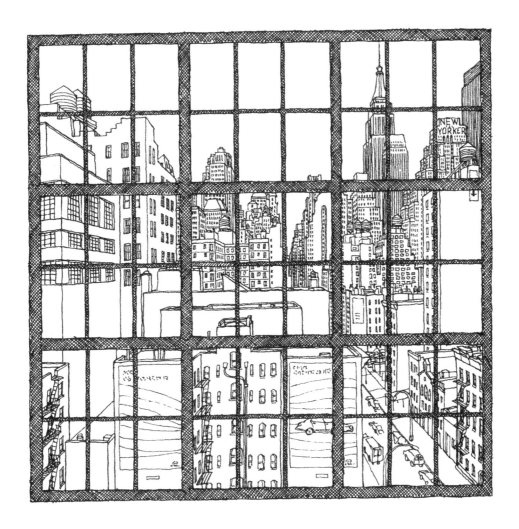

RICHARD MEIER

看著這張素描，
我發現我的窗景本質上是由其他窗口組成的。
這麼一來，它提醒了我：
人們總是互相觀看著。
從那些窗口往外望的人，都是他的視野的主宰，
就像我是我的視野的主宰一樣。
每一扇窗不論就形而下或形而上來說，
都代表著一個觀點；
每個憑窗眺望的人看到什麼，全操之在己。
然而每一扇窗，就像每一個主觀意識一樣，也是一種障礙，
象徵著我們把自己侷限在自身之內的那堵牆。
我們可以看著彼此，
甚而盯著對方的眼睛（所謂「靈魂之窗」），
但我們無法變成對方。
所以，一面窗景，就像平常所見的任何事物一樣，
把我們和這世界及其他人連結在一起，
同時也把我們和這世界及其他人分隔開來。

Looking at this drawing has made me look at the view it shows as essentially a view of other windows. In this way it reminds me of people looking at other people. Each person looking out any one of those other windows is the master and commander of his view, as I am the master and commander of mine. Every window is literally and metaphorically a point of view, and everyone who looks out a window is a sovereign of what he sees. But each window, like each subjective consciousness, is also a barrier—it stands for the wall that keeps us restricted to our own selves. We can look at each other, even peer into the eyes (the 'windows') of each other, but we cannot dwell in each other. So a view, like vision in general, at once connects us to and separates us from the world and other people.

丹尼爾・米納克｜出版人、作家

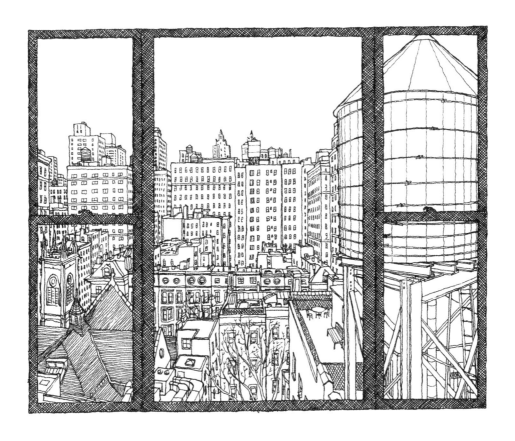

DAN MENAKER

每天早上我都跟自己説真希望可以住高一點。
但我知道就算我住在頂樓，
還是會説同樣的話。

Every morning I say to myself that I wish I could be higher. But I know that I
would say the same even if I were on the top floor.

安東尼奧・孟達 | 作家、教授

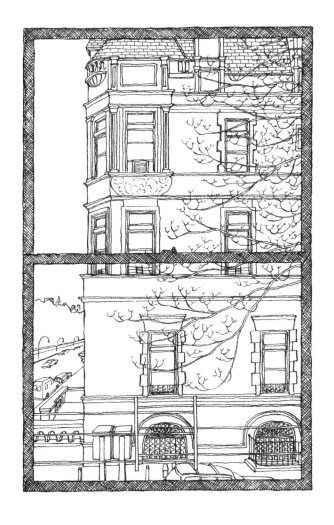

ANTONIO MONDA

這是鐘塔大樓，
建於一八九四年，屬於一家保險公司，
如今被列為古蹟。
樓的立面是史丹佛·懷特設計的，
目前是市政府刑事法庭所在地。
巷內時常傳來群眾爆發肢體衝突的吶喊聲，
讓我猜想法院判決不見得人人都信服（這種事沒什麼好意外的）。
我曾經失手把朋友點燃的雪茄揮落窗外，
不料它竟掉到一名睡覺的流浪漢身上並起了火，
之後有好幾台消防車湧進巷子救火。
幸好他沒燒傷，
一名消防員告訴我，
這多少是因為他的衣服是防燃布料做的。
即便他只受到最輕微的灼傷，
我還是嚇出一身冷汗。
後來我們結為朋友，
之後每年冬天我都送他外套穿（我猜布料都不是易燃的）。
鐘塔大樓特別迷人的地方，
是它在每個整點仍會鳴起宏亮的鐘響，
這在我們的時代已經不合時宜。
我從這面窗口往外望的十二個年頭來，鐘聲從無延誤。
我工作時聽著它報時，
睡夢中也聽到它。

This is the Clock Tower Building. It was built in 1894 for an insurance company and it is a designated historical landmark. The facade was designed by Stanford White. It is now used by the city for Criminal Court. There are often fistfights and screaming matches in the alley, leading me to suspect that the court's decisions, not surprisingly, are not always well received. I once threw a friend's lit cigar out the window and it landed on a sleeping homeless man who subsequently caught fire, and many fire engines squeezed into the alley to extinguish the flames. He was not hurt, in part, a fireman told me, because his clothes were fire retardant. I was horrified that I had caused even the slightest burn, and we became friends (I give him a winter outfit each year, which I suspect is not inflammable). The particular charm of the clock tower is that it anachronistically rings the hour with loud peals. In the twelve years that I have looked out this window, the bells have never failed. I hear them while I am working and I hear them when I sleep.

蘇珊娜·摩爾｜作家

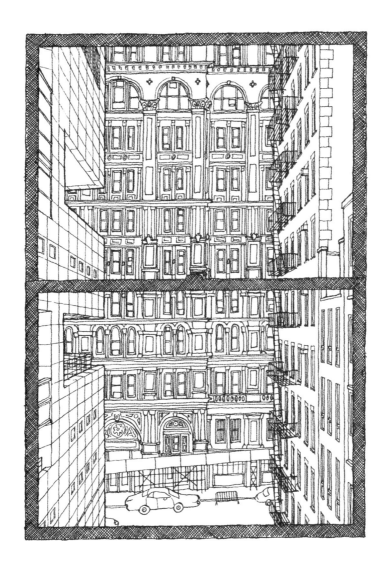

SUSANNA MOORE

這就是從我家窗口看出去的景象：
對街那棟公寓，
住戶搬進搬出的頻率很驚人，
形形色色的人在裡頭換衣服、看電視、用各種姿勢做愛。
帝國大廈頂端的遊客常朝我們公寓的方向按快門亮閃光。
真不知那些相片看起來如何。

Here is what I see from my apartment window: the apartments across the street that, with alarming regularity, empty and then refill with new people who change clothes, watch television, and have sex in a variety of ways. Tourists at the top of the Empire State Building take flash photographs of me in my apartment. I wonder how they turn out.

馬克‧莫里斯｜編舞家

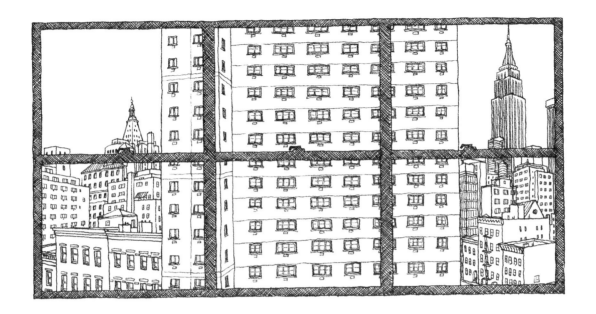

MARK MORRIS

我看到這個很有意思的中國社區，
每天早上都會有幾位老婦人在那片庭園裡用慢動作練功。
往左望可以看到克萊斯勒大樓。
我剛搬進來那陣子，
還可以看到帝國大廈，
後來有人蓋了一棟很誇張的飯店，
正好擋住了它，
所以現在我只能看到它由下方燈光微微照亮的尖頂。

I can see this amazing Chinese apartment block; every morning, old women perform slow-motion martial arts in the courtyard. If I look left, I can see the Chrysler Building. When I first moved in, I could see the Empire State Building, but then people built a ridiculous hotel directly in the way, so now all I can see is the spire, gently illuminated from below.

尼可‧馬利｜作曲家

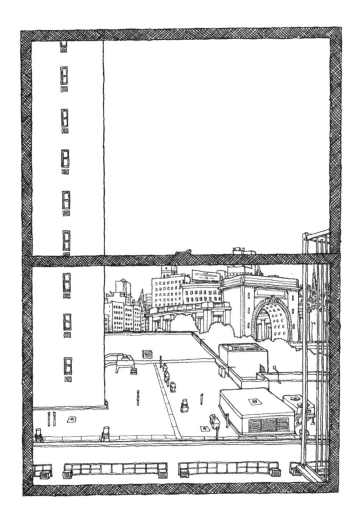

NICO MUHLY

我大半輩子都住在紐約（曼哈頓和布魯克林），

而這是我至今最愛的一幅窗景，

雖然我曾住過U字型結構的公寓，

從我這頭的臥房可以望見家人在另一頭的廚房裡活動的情景，

讓我感動莫名，

感覺有點像在偷窺偷聽自己的生活。

眼前這個窗景配有音效：

教堂鐘聲會定時響起，

聲音不大，卻溫和地提醒你時間的流逝。

後院的樹都很老了，

風一吹便咯吱搖晃，發出嘆息似的沙沙響。

我寫詩時，

偶爾會從這些天然或人造的呢喃聲中擷取靈感。

I've lived in New York (both Manhattan and Brooklyn) most of my life. This is my favorite view from any window I've ever had, though I once lived in a U-shaped apartment building, and it was very moving to be able to glimpse my family in the kitchen from my bedroom. A little like eavesdropping on your life. This view has an auditory component: the church bells ring periodically; they're not too loud, but serve as a gentle reminder of time passing. And the trees in the backyard of the house are very old, so they seem to creak in the wind and rustle and sigh. When I'm writing poetry, all this natural and manmade muttering can be an inspiration at times.

梅根‧奧羅奇 ｜ 作家、詩人

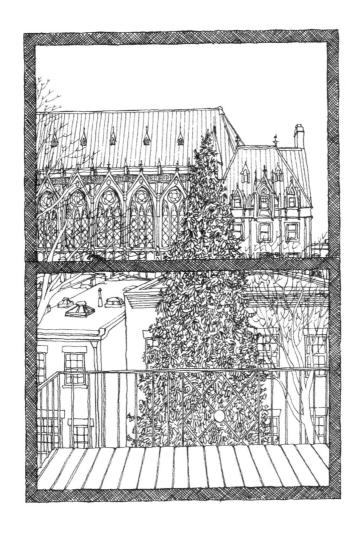

MEGHAN O'ROURKE

我希望窗外的景色只要引起我適度的興趣就好，

也就是說，別讓我太著迷。

我絕不可能在海邊小屋裡工作（怎麼可能辦得到？），

我準會不時踱到迴廊上，看永恆而美麗的浪花看得出神。

山間小木屋也一樣，行不通的。

我很高興自己隱身在這層四樓公寓的後方，

面向安靜的後院，

這裡看得到五棵樹、幾座陽台，以及無數扇窗戶。

偶爾（真有需要時）我會打打哈欠、伸伸懶腰，倚著窗往外瞧，

看看我的鄰居或他們養的幾隻貓在幹什麼；

可能有人正在更換露台上的破爛傢俱、洗刷窗戶，甚至裝潢臥室。

看到什麼其實都不打緊，

因為到頭來，我的目光總會往那一小片多邊形的天空游移。

這幻化無常的天空，

就像名畫一般被完美地鑲了框。

What I require from a view out my studio window is just the right amount of interest, that is to say, not too much interest. I could never work in a cottage by the sea. How could I? I would always be out on the porch, enraptured by the beautiful face of the timeless waves. Ditto for mountains. No. I am happy to be ensconced on the fourth floor, in the back of my building, facing a quiet court-yard with about five trees, a handful of terraces, and numberless windows. Occasionally, if I really feel the need, I can yawn and stretch and then stand by the window to have a look-see at what my neighbors or their few cats are doing; perhaps someone is replacing their ratty deck furniture, or washing a window or even building a bedroom. It never really matters because in the end, I always let my eyes meander to the small polygon of changeable sky, perfectly framed like the masterpiece it is.

克利斯・拉西卡｜插畫家

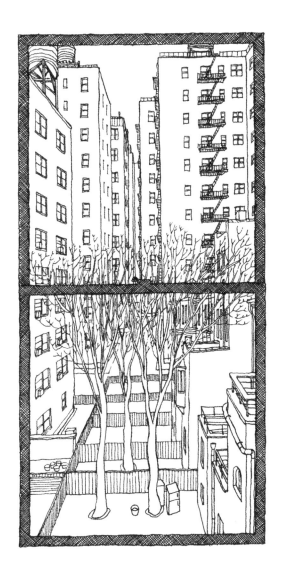

CHRIS RASCHKA

對街一棟棟整齊又緊緊相挨的建築、

老舊的赤褐砂石樓房與其門階、

街道旁成排的銀杏——

這一切在在讓我感到踏實與平靜。

不過,

若我低頭俯視十三街和格林威治大道交會的繁忙街口,

也會看到並聽到紐約市一成不變的活動與生活,

例如腳步匆忙的人拎著皮包、閒聊或抽菸、遛狗、停車。

大得離譜的貨車幾乎堵住交通,

尖聲刺耳的消防車急馳而過,

人行道地底下 A 線地鐵在隆隆作響。

我的打字機放在窗前的書桌上,

只要我坐下來寫東西,

就會看到這片景象。

我想我需要川流不息的城市生活來激盪我思考、寫作。

The interlocking symmetries of the buildings across the way, the old brownstones with their stoops, the ginkgo trees which line the street—all this I find solid and calming. But looking down at this busy corner of Thirteenth Street and Greenwich Avenue, I also see and hear the constant movement and life of New York City—people hurrying, carrying bags, idly chatting or smoking, walking their dogs, parking their cars. Impossibly large trucks making the tight corner, noisy fire engines screaming by, the A train rumbling beneath the pavement. My typewriter desk sits in front of the window, so this is the view that faces me whenever I sit down to write. I think I need the ever-moving flow of city life as a counterpoint to my own thinking and writing.

奧利佛‧薩克斯 | 腦神經學家、作家

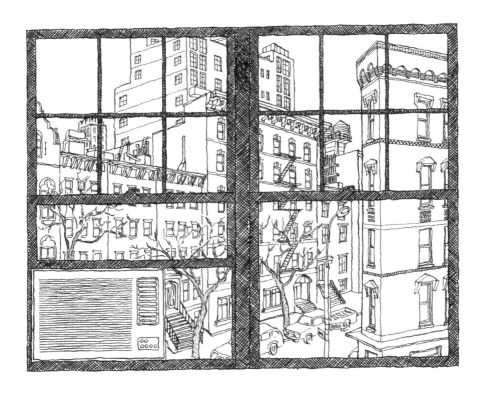

OLIVER SACKS

一九九三年回到紐約時，
我想找個好地方，
它能讓我們工作室裡的每個人，
時時感受到自己正生活在紐約市的事實。
紐約是現代都會的經典代表，
而帝國大廈是舉世摩天樓的終極象徵。
當我們打算在這工作室裡度過生命中最重要的菁華時光，
這片景致將我們和外頭的世界連結在一起，
而外頭世界裡的天氣和光影時時在變化，
為我們營造出生動百變的工作環境。

When I returned to New York in 1993 I wanted to get a place capable of reminding all of us in the studio that we live in New York City on a daily basis. New York is the classic symbol for the modern city with the Empire State Building, the ultimate icon, summing up all skyscrapers. As we tend to spend significant parts of our lives in the studio, the view keeps us connected to the outside world with the changing weather and light situations creating a lively and always different working environment.

史地芬・薩格梅斯特｜平面設計師

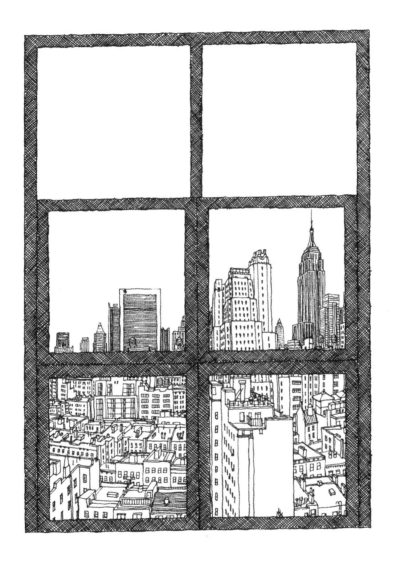

STEFAN SAGMEISTER

我都是在沙發上或床上寫東西，
抬起頭就看見遠方的紐約金融區——
那一條由伍爾沃斯大樓華麗的哥德式塔冠，
以及由玻璃與鋁金屬打造的曼哈頓大通銀行大樓所屬之巨型街區
所撐起的天際線。
這些日子，
我會想到在那些窄巷裡釀成金融風暴的金融大樓
（美國資本家走上衰敗的大本營）
而它就在我放眼所及的範圍內，
感覺很詭異。
摩天樓群下方那些比較靠近我的低矮紅磚建築，
夜裡傳出誘人的拉丁音樂和愉快的喧鬧聲，
讓我想起紐約有很多面，
當中至少有一面是我很喜歡的。

I write on my couch or in my bed, and when I look up from my work I see the distant skyline of New York's financial district, bracketed by the magnificent Gothic crown of the Woolworth Building and the gargantuan glass-and-aluminum block of the Chase Manhattan Bank Tower. These days, I speculate on the financial disaster building in the narrow streets—how strange that America's capitalist demise is headquartered within my sight. And closer to me, right below the canopy of skyscrapers, some short redbrick housing projects beckon with Latin music and happy shouts in the night, reminding me that there are many New Yorks, at least one of which I love.

蓋瑞・史坦恩加特｜作家

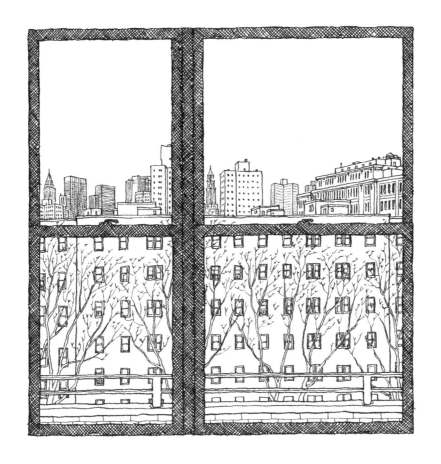

GARY SHTEYNGART

我在為書本畫插圖的好幾星期甚至好幾個月內，
望出去就可以看到真實的世界，感覺很不錯。
模特兒、毒梟，以及對街天主教學校裡的小學生。
幾隻狗（其中一隻的後腿裝了一組輪子）喧鬧地跑過。
我都從窗口看到些什麼？
抬著聖安多尼或聖格納羅雕像行進的隊伍和樂隊；
伊莉莎白街上愚蠢的停車號誌釀成的追撞車禍；
從包厘街（東邊的下一條街）晃過來的遊民、人妖和乞丐。
小酒館、五金行和修鞋店，漸次變成一家家的精品店。
我看過達斯汀・霍夫曼在逛街，康乃狄克鬆糕店的老闆被射殺身亡，
義大利籍老婦坐在阿爾巴尼亞肉舖外的椅子上。
馬丁・史柯西斯在那棟樓長大，悶熱的夏天夜晚就睡在火災逃生梯上。
我家廚房正下方的廉價小館，閒置多年後變成了時髦餐廳「哈瓦那小館」。
公寓大樓像磨菇般一朵朵冒出來，
從前常見的滿臉皺紋老藝術家慢慢消失了。
我家公寓樓下的顏料店變成了手提包精品店。
看來以後我得用麥克筆作畫了。

When I am drawing pictures for a book over many weeks or months, it is nice to look outside and see the real world. The models and junkies and kids from the catholic school across the street. The dogs—one of them has a set of wheels instead of hind legs—romping by. What have I seen from my window? Marching processions and bands with statues of St. Anthony or San Gennaro; lots of car crashes because of a silly stop sign on Elizabeth Street; lots of bums, transvestites, and panhandlers from the Bowery, the next street to the east. The transformation of a bodega, a hardware store, and a shoe repair shop into boutiques and more boutiques. Dustin Hoffman shopping, the owner of the Connecticut Muffin café shot to death, an old Italian lady sitting on her chair outside the Albanian butcher shop. Martin Scorsese grew up in that building and slept on the fire escape on hot summer nights. After years of emptiness, the greasy spoon just below my kitchen became a trendy café, the Cafe Habana. Condo buildings are growing like mushrooms now, and old wrinkly artists of the past are disappearing. The pigment store under my studio became a handbag boutique. I will have to draw with markers now.

彼得・席斯｜插畫家

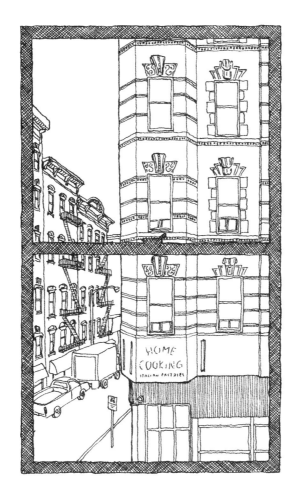

PETER SÍS

這窗面向西南，
也就是說，會有大量的陽光透進來。
這在城裡可是很稀罕的。
這面景的下半部，
是一大片十九世紀低矮樓宅的屋頂，
林立於西七十六街和七十七街之間。
打從我們這棟樓在一九二七年蓋好以來，
這個景就沒什麼變，非常賞心悅目。
稍遠處有一棟和我們這棟同時期蓋的公寓大樓，
它的優點是有個老式的木製水塔。
對內人和我來說，
幸好川普名下的現代大樓──那些布滿醜陋窗孔、龐大得囂張的高樓，
只在遙遠的角落現身。
這個窗景最讓我們自豪的，
是可以看到壯麗又陰晴無常的哈德遜河，
儘管在我們這裡中間偏右處可見的河景不大。
二十七年的婚姻生活中，
我們在這裡飽覽無數日落，
偶爾瑰麗得懾人魂魄。
其他日子則是單純的美麗。

It's a southwest-facing window and that means plenty of sunlight, a rarity in this city. The lower part of the view shows the rooftops of the small nineteenth-century houses that line West Seventy-sixty and Seventy-seventh streets, a view pretty much unchanged since the time our building went up in 1927, and that is very pleasant. In the near distance is an apartment building contemporary with ours that has the merit of featuring an old-fashioned wooden water tower. Fortunately for my wife and me, the modern buildings of Donald Trump, with their ugly fenestration and hostile immensity, figure only in the distance. The glory of our view is the lordly, moody Hudson River, much reduced here in the middle right. For the twenty-seven years of our marriage this has afforded us sunsets that on some days are spectacular, on others merely beautiful.

班・桑南柏格｜作家、編輯、譯者

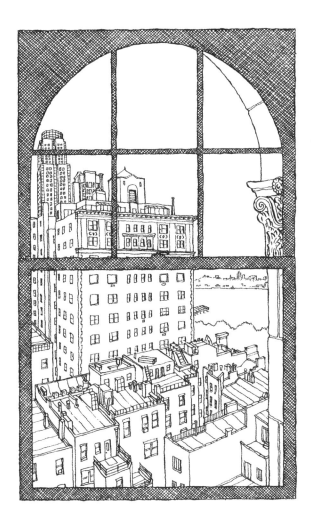

BEN SONNENBERG

我的朋友大多住在小公寓裡，但都沒我的這麼小。
屋裡頭有一張書桌、一張床和兩張直背椅，
除此之外，根本沒辦法再騰出其他空間，例如吃飯的地方，
連窗景也很小。
天井對面的鄰居──可以從他的窗口望進去的那一戶，
在餐館工作，晚上才上班。
我白天要是待在家，常會聽到他放交響樂，
並跟著旋律引吭高歌（不是哼哼而已，是真的放開嗓子唱）。
我有兩次必須設法嚇走爬上逃生梯的竊賊，
幸運的是我沒什麼值錢的東西可偷。
後來我家隔壁蓋了那種公寓大樓，
看起來就像疊了二十三層的水族箱，
只是裡頭住的是人不是魚。
我要是竊賊，這絕對會讓我打消念頭。
此外，我還得說一句：
是馬帝歐讓我動手把家裡的兩扇窗刷洗乾淨，並換上木質百葉窗。
彷彿「人生仿效藝術」這句話的另一個寫照──
多虧了他，這個景（當他作畫時，它還藏在骯髒的窗簾後頭）
之後為我帶來了莫大的歡喜與安樂。

Most of my friends live in tiny apartments, but mine is the smallest. It holds a desk, a bed, and two straight-back chairs, but there is nowhere, for instance, to eat. Even the view is small. My neighbor across the courtyard (the one whose window you're looking into) works nights, in a restaurant. If I'm at home during the day I often hear him playing symphonies and singing—not humming, really singing—along. Twice I have had to scare strangers off my fire escape. Luckily I have nothing worth stealing. And now they've put up one of these big new condos next door; it looks like a twenty-three-storey stack of aquariums, only with people instead of fish. If I were a burglar, it would certainly deter me. The other thing I should say is that Matteo inspired me to wash my two windows and screw in a pair of wooden blinds, and in yet another case of life imitating art, thanks to him, this view (which when he drew it I always kept behind dirty curtains) has for me become a source of great pleasure and well-being.

洛林・史坦 ｜ 編輯

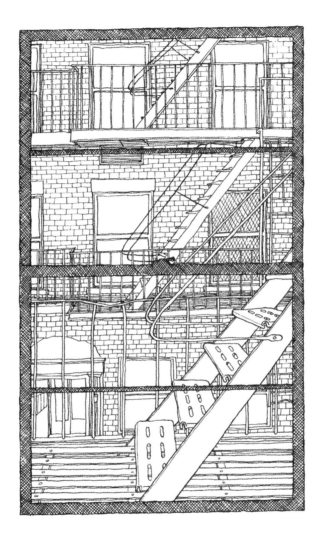

LORIN STEIN

「採光真棒！」
頭一次來到我辦公室的人，
最先脫口而出的都是這句話。
陽光的確是傾瀉而入。
這片落地窗有十五呎高，
面南朝向哥倫比亞校園的一個方形廣場。
窗前有棵樹，
要是我站起來，可以看到傑佛遜總統雕像，
而且，尤其是每到下午，光線會把我淹沒。
說真的，大半時候我都很討厭這個景，也討厭這陽光。
中午過後，尤其是夏天，
有時候連冬天最冷的那幾天也一樣，陽光就往我頭頂上猛灌。
天氣比較熱的那幾個月，
午後兩點到四點間的太陽簡直就要把我的腦袋曬到融化，
根本沒辦法思考。
為了擋掉陽光，我裝上了兩組窗簾，
其中一層是全黑的厚布簾，可以完全阻斷光線。
一到下午，我多半會把布簾完全放下，
在黑漆漆的洞穴裡靠人工照明來工作。
所以說呢，我待在這辦公室的大半時間，
都在跟這面景色搏鬥，跟陽光搏鬥，
想盡辦法教自己別理會它。

"What great light you have!" is often the first reaction of people seeing my office for the first time. Light does, in fact, come pouring in. I have fifteen-foot floor-to-ceiling windows looking south onto a quadrangle of the Columbia University campus. I can see a tree and, if I stand up, a statue of Thomas Jefferson, and, especially in the afternoon, I am flooded with light. The truth is, most of the time I hate my view and all this light. In the afternoons—especially in summer but even in the coldest days of winter—the sun comes pounding on top of my head. In the warmer months, between the hours of two and four, my brain seems to melt and I am literally incapable of thought. To combat the light, I have two sets of shades. One of them is a heavy, black matte shade that allows no light at all. And during most afternoons, I pull it all the way down and work in cavernous darkness with artificial light. So, I spend a good portion of my time in this office fighting the view, fighting the light, and doing my best to ignore them.

亞歷山大・史迪里｜作家、記者

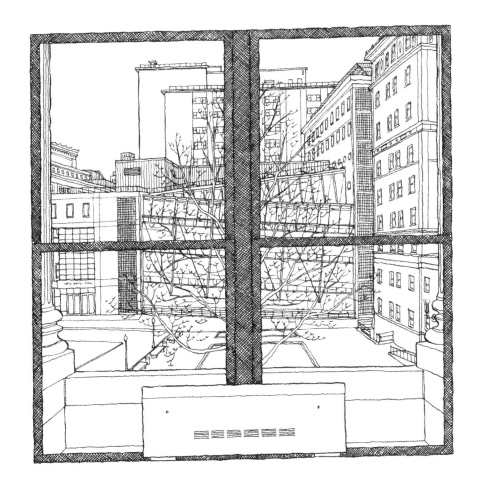

ALEXANDER STILLE

當天色暗下來、外頭的燈光慢慢點亮，
彷彿一片魔幻之海浮現了——
是風之海，還是水之海，其實都無妨。
那是一片魔幻的閃爍星海，
而每顆「星」都代表了某個人（某些人）。
我喜歡！

As the lights begin to come on and the sky darkens, it seems a magical ocean appears—of air, of water; it hardly seems to matter—it is an ocean with its own magical twinkling stars. And yet each 'star' represents people. I love that.

伊莉莎白・史卓特｜作家

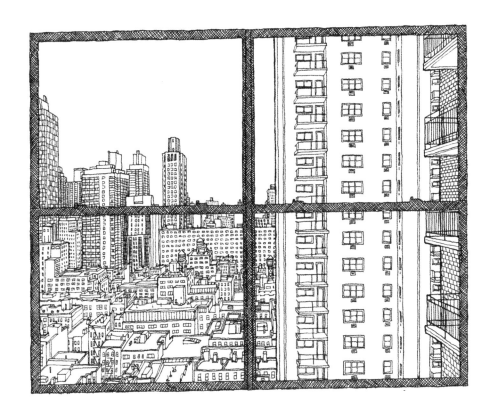

ELIZABETH STROUT

我的視線穿過這片最先進、超透析的玻璃，
看見的是舊紐約的美妙風情，
有雄偉的帝國大廈、鎮日鬧哄哄的成衣區，
以及第八大道上繁忙的上城。

I peer through state-of-the-art, ultraclear glass revealing wonderful, old New York with its majestic Empire State Building, a constantly bustling garment district, and an Eighth Avenue hurrying uptown.

小亞瑟・奧克士・沙茲伯格｜《紐約時報》發行人

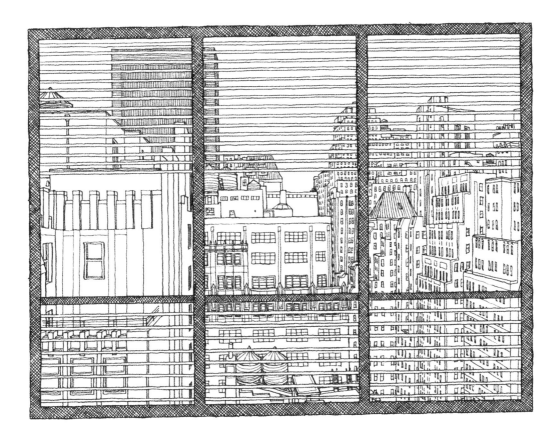

ARTHUR OCHS SULZBERGER JR.

從位於曼哈頓中城的這一棟赤褐砂石樓房四樓往外看，
鄰近的街景看上去頂多就是朦朦朧朧的。
這得怪我很久沒雇人洗窗了。

幾年前，我偶爾會雇人來洗窗子。
那些工人從不準時，讓我一等就等上好幾個鐘頭。
當我終於把心思拉回寫作上，卻又會被門鈴聲打斷。
等這些工人扛著水桶，
一邊氣喘吁吁一邊發著牢騷爬四層樓階梯上樓來，
然後打開窗子清洗外部玻璃時，
他們腳上的膠鞋底，
也把蟲害防治人員安裝在窗台上的那幾排防鴿釘踩平了。

就這樣，
聒噪的鴿子重新取回我這片窗台的探視權，
窗玻璃蒙上塵埃和鳥糞，
窗外世界變得乳白而不透光，
就像莫內的畫一樣，
讓我很難說清楚外頭有什麼，
只能任憑自己想像。

While glancing through the fourth-floor studio window of my brownstone in mid-Manhattan I have at best a murky view of my neighborhood due to my longtime avoidance of window washers.

Many years ago, when I occasionally did employ window washers, the men would never arrive on time; and hours later, after I had finally gotten back to my writing, my concentration would be interrupted by the doorbell and then by the men's heavy breathing and grumbling as they climbed the four flights of steps with their buckets—and finally, after they had opened the window to wash the front part of the pane, they would flatten with the soles of their boots the rows of upright nails on the ledge that had originally been cemented there by a pest control crew to prevent the roosting of pigeons.

And so now the noisy pigeons have regained their visitation rights to my ledge, and my window is darkened with dirt and bird droppings, and my view of the outside world is rather opaque and opalescent, like a Monet painting, and it is difficult for me to describe what I see since so much is left to my imagination.

蓋伊·塔利茲 | 作家

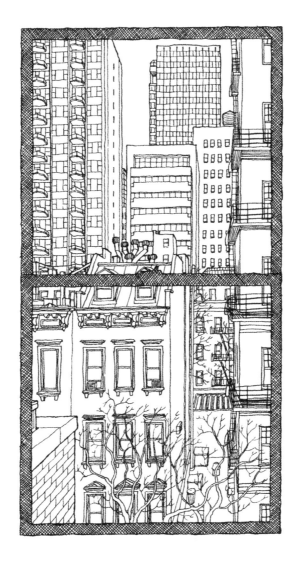

GAY TALESE

世間萬物總有裡外之分，
因此也總有分隔裡外的界線，
即使我們假裝這道界線不存在。
這道界線時而像磚牆一樣又厚又硬，
時而薄而無形，
一如我們的視野，或想像的限度。
我經常思忖：
這道界線究竟屬於裡，還是外？
我和世界之間的界線，
是我的一部分，還是外在的一部分？
我沒有答案。
但是我愛我的窗，
也會繼續盯著玻璃看，
因為它提醒我這個問題很重要。

There is always an inside and an outside. And there is always a boundary sepa-rating the two, even if we pretend otherwise. Sometimes it is as thick and stub-born as a brick wall. Sometimes it is as thin and immaterial as the visual field, or the limits of our imagination. I often wonder: does it belong to the inside or to the outside? Is the boundary between me and the rest of the world a part of me, or is it out there? I don't know the answer. But I love my window and keep looking at its glass, for it reminds me that the question is an important one.

阿基雷・瓦爾茲｜哲學家

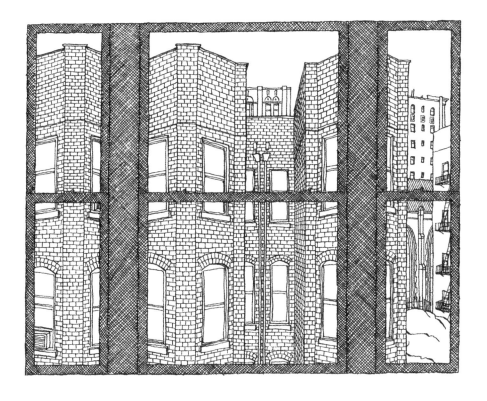

ACHILLE VARZI

（説到我的窗景）當然得提到那個有如檯燈頂飾一般的水塔，
還有層層往天空堆疊的屋頂。
很多窗子的窗簾是拉上的，給人一種休眠中的感覺，
只有一個人會不定時現身。
那是個名人，夜裡有時會在某個房間裡坐著。
那房間的牆上掛滿他的獎狀，
很像醫生診間掛的一張張證書。
房裡點著柔和的光。
我數過，他的公寓有二十個房間，
所以他常在那個房間度過一天的最後時光，
肯定有他的理由。
遇上我熬夜的夜晚，
偶爾會看到他像影子般飄過那些窗前，
那房裡的燈也隨之熄滅。
後來那層公寓賣掉了，他以前常待的房間如今是小孩房，
而且就我這裡看去，牆上空空如也。
後來我很少再往那公寓裡張望了。

The water tower, of course, like a finial on a lamp. And the rooftops leading to the sky. Many of the windows have shades that are drawn, giving them a quality of dormancy. I see only one figure with any regularity, a famous man who sometimes sits at night in a room in which there are collections of his awards on the wall, like diplomas in a doctor's office. The room is softly lit. I have read that there are twenty rooms in his apartment, so there must be some reason he chooses so often to end the day in this one. On nights I stay up late I sometimes see him pass like a shadow in front of the windows and then the light in the room go out. The apartment was sold and the room where he sat is now a child's bedroom with, so far as I can see, nothing on the wall. I hardly ever look over there anymore.

亞歷・威金森｜作家

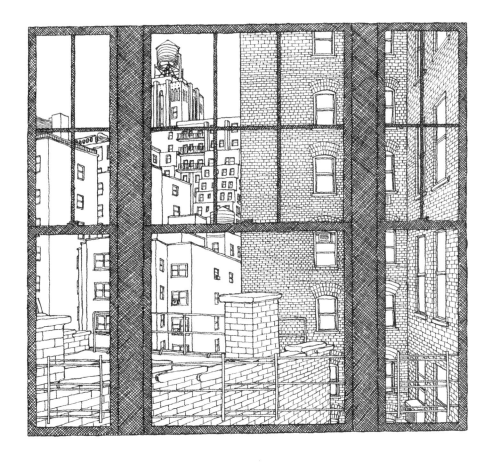

ALEC WILKINSON

一位房地產仲介商帶我們夫婦看過三十四間公寓，
最後我們買下你現在看出去的這一層。
我們看到第二十九間時，
她對我說：
「你有沒有發現，
每次我帶你看房子，
你從沒看內部一眼，
總是直接衝到窗邊看風景。」
一直到今天，
我還是沒仔細瞧過這間公寓，
只清楚窗外的風景是什麼樣子。

A real estate agent had shown my wife and me thirty-four apartments before we finally took the one you're looking out of right now. When we had reached twenty-nine she said to me, 'Do you realize that every time I show you an apartment, you never look at it? You rush straight to a window to assess the view.' To this day, I haven't really seen this apartment, only what's outside of it.

湯姆・沃爾夫 | 作家

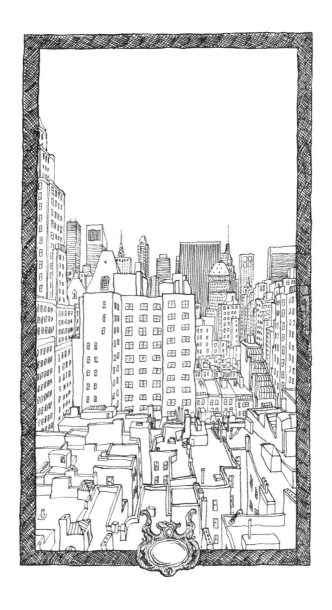

TOM WOLFE

在這樣一個繁華擾攘的都會裡，

回到家來，看看窗外，欣賞哈德遜河，

是讓人很舒坦的事。

為何凝視那寬敞的河面能有如此的效果，

我說不上來，

也不曉得我們能擁有這個景致多久。

在紐約市裡，

遲早會有人在你家窗外蓋起高樓大廈。

我們真夠幸運了，

已經享受這個景十年，

希望這運氣可以再持續久一點。

In a city with so much going on it feels calming to come home, look out the window, and see the Hudson River. I'm not sure why, but looking at a large body of water seems to do that. I don't know how much longer we'll have this view. In New York City it's only a matter of time before someone builds in front of you, but we've been lucky enough to enjoy our view for ten years, and have hopes it will last a bit longer.

亞當・賈克 | 樂手

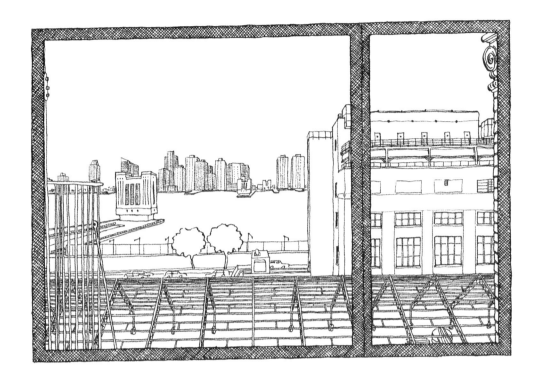

ADAM YAUCH

窗外的這個景呈現了紐約市的過去與未來。
我們住在十九樓，就下城來説，算是住得很高。

窗外依法必須安裝護欄（上頭覆著一層煤灰），
提醒我們家裡的孩子還很小。
我們恐怕永遠都沒辦法安心把窗戶往上推到全開，不管孩子長到多大。
其實我們還有個大陽台，它當然更是時時暗藏危險，
所以説，只擔心那扇窗是很沒道理的事。

這扇窗在廚房裡，它是我們一家的交流活動中心，
我們在這裡工作、打發時間、一起開心用餐。
我們常一起欣賞窗景，不分白天晚上，懷著各式各樣的心情。

我們可以看見古博聯合學院的大禮堂。今年秋天歐巴馬就在那裡演講過。
林肯、格蘭特、克里夫蘭、塔夫特以及羅斯福總統選上之前，
也都在那裡演説過。

我們看到曼哈頓的指標性大樓——華納麥克百貨公司的增建部分，
一個世紀前它可是百貨業的龍頭。
如今裡頭是一些倒閉的網路公司辦公室，以及一家凱瑪零售百貨。

我家族的先人在下東區和布魯克林住過的克難移民公寓，
正陸續被改建為亮晶晶的住宅大樓，將來會有我們這樣的人入住。
我們很愛盯著建築用起重機看。

The view out this window represents both the history and the future of New York City. We are on the nineteenth floor. Downtown, that is high up.

Our legally mandated, soot-covered window guard reminds us that our kids are still small. We worry that we'll never feel safe opening up the windows wide, from the bottom, no matter how old the kids get. We also have a big terrace, which of course is a danger all the time, so that fear is pretty unfounded.

This window is in the kitchen, the highly trafficked nexus of work space, leisure space, and general gustatory enjoyment. We look out this window a lot, at all times of day and night, in all kinds of moods.

We can see the Great Hall at Cooper Union. Barack Obama spoke there this past fall. Before they were elected, presidents Lincoln, Grant, Cleveland, Taft, and Theodore Roosevelt also spoke there.

We see an iconic Manhattan building, the annex to the Wanamaker Department Store, which a hundred years ago was dominant in its industry. Today it is home to defunct dot-com offices and a Kmart.

The tenements of my grandparents' Lower East Side and Brooklyn roots are being built over by shiny apartment towers that people like us will live in. We love looking at construction cranes.

勞倫・扎拉茲尼克｜媒體主管

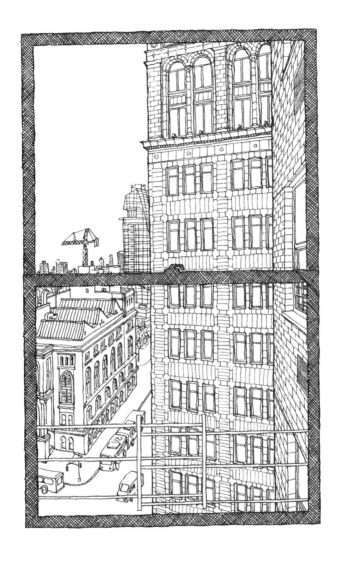

LAUREN ZALAZNICK

窗框內那片薄玻璃之外的一切，
屬於我們內心，不屬於外在世界

二〇〇四年春，內人和我準備搬離我們位於曼哈頓上西區、住了七年之久的公寓。那些年間，我大部分時間都待在一個畫室兼臥房的空間裡，睡醒了就工作，工作累了就睡。日子一天天過去——我不停把東西從桌上搬到床上，再從床上搬到桌上——我經常下意識地停下手邊的事，沒來由地望向窗外。

我們的窗景很簡單：低矮的屋頂兩側連著稍高的大樓（沿著河濱路和西側大道林立的樓宇），北邊可見河畔教堂的尖塔。這很像一條峽谷，幾座水塔錯落其中。

一天，我們差不多打包好了，我記得我又往那窗景看了一回，瞬間被一種連自己也不解的失落感震懾住。「我不能丟下它！」我對自己說。在試著理解自己何以突然捨不得離開的同時，我估算了一下：七年下來，我大概花了六百四十個鐘頭看著這個窗景，也就是說，不眠不休的話是連續二十六天以上。我心想：「要是這個景是貼在玻璃上的薄膠膜，我只要撕下它、捲起來帶走，然後重新貼在新房子裡就好了。」

最後，我決定用相機從屋內各個可能的角度把它拍下來。拍攝窗景意味著把窗框一併拍進去，因為沒有框架就沒有所謂的「窗景」。那特定的開口，在特定大小的框架內（窗戶），位於牆上的特定位置，距離地面特定的高度——就像一個被某種精巧鷹架固定在高空的傳統相機暗箱（camera obscura）——打造出獨一無二的紐約風景。而且，唯有把它畫下來，我才能把各個角度的景象融合在一個框裡。

畫好之後，我開始思索所謂的窗景；想想看，這城裡每一扇窗看出去的風景——由其他樓宇、屋頂、摩天樓、水塔等構成的獨特組合——都是舉世無雙的！況且，每一面風景都牽動著它的「主人」，就像我的窗景緊扣著我的心一樣。

「要是我可以把它們全都畫下來該有多好？」一開始我的確異想天開。我當然做不到，不過，在這念頭的帶領下，我拜訪了上百間公寓、辦公室或工作室，欣賞窗外風景，並將之拍下來。此外，我也刻意找了些和紐約很有淵源的人——也許是住在這裡，也許是在這裡工作——他們眼中的紐約肯定別有意義。當中的六十三幅窗景，就收錄在本書裡。

我總覺得本書所呈現的，是「隱形」的紐約：你唯有「住到某人的腦袋裡」，至少一會兒，才能真正領略這些景致。

本書的封面，是插畫家索爾·史坦伯格（Saul Steinberg）先生窗外的風景。他是我迷上繪畫後的第一個偶像。這本書少不了他的窗景，因為他的繪畫最能教會我們如何欣賞這座城市。

然而，實際上，他的窗景也是最難取得的一個。在索爾·史坦伯格基金會和他一些友人的協助下，我找到史坦伯格先生生前最後一間畫室座落何處，不料大樓警衛硬是把我們擋在門外，斷然拒絕將我的請求傳達給現任屋主。他無疑把我的請求當成某種怪癖，視為侵犯他人隱私之舉。後來，我湊巧得知那公寓要出售，於是和仲介約了看房子，她也好心地同意帶我入內拍攝窗景。結果卻還是行不通：堅守在大樓入口處的警衛認出我來，把我攆走。最後是我太太和她一位朋友，假裝有意買屋才矇騙過關，替我進到屋內去拍照。

剛才我提到了隱私。有好幾回，拒絕參與我這項計畫的人，給出的理由讓我聽起來比得到他們許可更開心。他們通常會這樣說：「很抱歉，我寧可不和別人分享我的私生活。」在我聽來，這很可以理解，也很有道理。畢竟，窗框內那片薄玻璃之外的一切，屬於我們內心，不屬於外在世界。

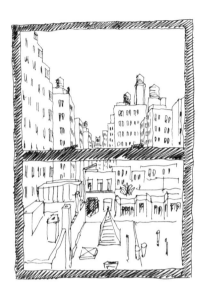

我 的 舊 窗 景

【Act】MA0014

紐約的窗景，我的故事
The City Out My Window: 63 Views on New York

作　　　者❖馬帝歐‧佩里柯利（Matteo Pericoli）
譯　　　者❖廖婉如
封 面 設 計❖鄭宇斌
總　編　輯❖郭寶秀
責 任 編 輯❖陳郁侖
行 銷 業 務❖李品宜、力宏勳

發　行　人❖涂玉雲
出　　　版❖馬可孛羅文化
　　　　　　104 台北市中山區民生東路二段 141 號 5 樓
　　　　　　電話：02-25007696
發　　　行❖英屬蓋曼群島商家庭傳媒股份有限公司城邦分公司
　　　　　　104 台北市中山區民生東路二段 141 號 2 樓
　　　　　　客服服務專線：(886)2-25007718；25007719
　　　　　　24 小時傳真專線：(886)2-25001990；25001991
　　　　　　服務時間：週一至週五 9:00 ～ 12:00；13:00 ～ 17:00
　　　　　　劃撥帳號：19863813　戶名：書虫股份有限公司
　　　　　　讀者服務信箱：service@readingclub.com.tw
香港發行所❖城邦（香港）出版集團有限公司
　　　　　　香港灣仔駱克道 193 號東超商業中心 1 樓
　　　　　　電話：(852)25086231　傳真：(852)25789337
　　　　　　E-mail：hkcite@biznetvigator.com
馬新發行所❖城邦（馬新）出版集團
　　　　　　Cite (M) Sdn. Bhd.(458372U)
　　　　　　41, Jalan Radin Anum, Bandar Baru Seri Petaling,
　　　　　　57000 Kuala Lumpur, Malaysia
　　　　　　電話：(603)90578822　傳真：(603)90576622
　　　　　　電子信箱：services@cite.com.my
輸 出 印 刷❖前進彩藝有限公司
初 版 一 刷❖2010 年 5 月
二 版 二 刷❖2015 年 12 月
定　　　價❖330 元（如有缺頁或破損請寄回更換）
版權所有 翻印必究

國家圖書館出版品預行編目 (CIP) 資料

紐約的窗景，我的故事 / 馬帝歐・佩里柯利著；
廖婉如譯 . -- 再版 . -- 臺北市：馬可孛羅文化出版：
家庭傳媒城邦分公司發行 , 2015.12
160 面；　公分
譯自：The city out my window
ISBN 978-986-5722-75-3(平裝)

1. 景觀藝術　2. 素描　3. 作品集　4. 美國紐約市

929　　　　　　　　　　　　　　　104024424